REMEMBERING

# DIANA

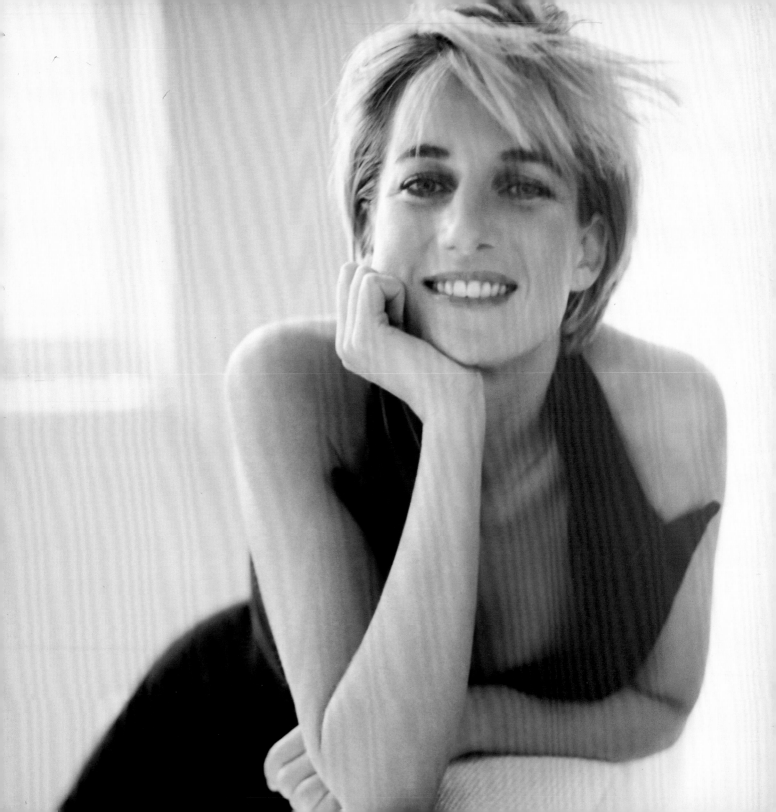

REMEMBERING

# DIANA

A LIFE *in* PHOTOGRAPHS

*foreword by*

## TINA BROWN

**NATIONAL GEOGRAPHIC**

WASHINGTON, D.C.

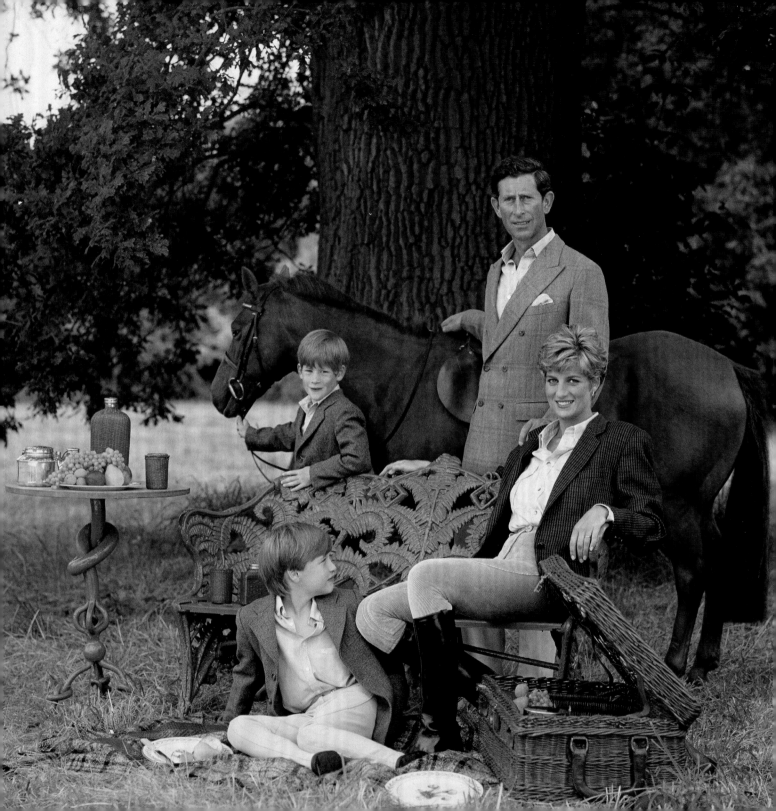

# CONTENTS

OPPOSITE: In this formal portrait taken by royal photographer Lord Snowdon, Princess Diana poses with her husband, Prince Charles, and their two sons, William (front) and Harry. *1991*

PREVIOUS PAGES: Famed photographer Mario Testino captured Diana's charm and personality during a portrait session for *Vanity Fair* in 1997. "Photographing Diana . . . was one of the most memorable days of my career," he said. "When she walked into the studio you could feel that someone special had walked in."

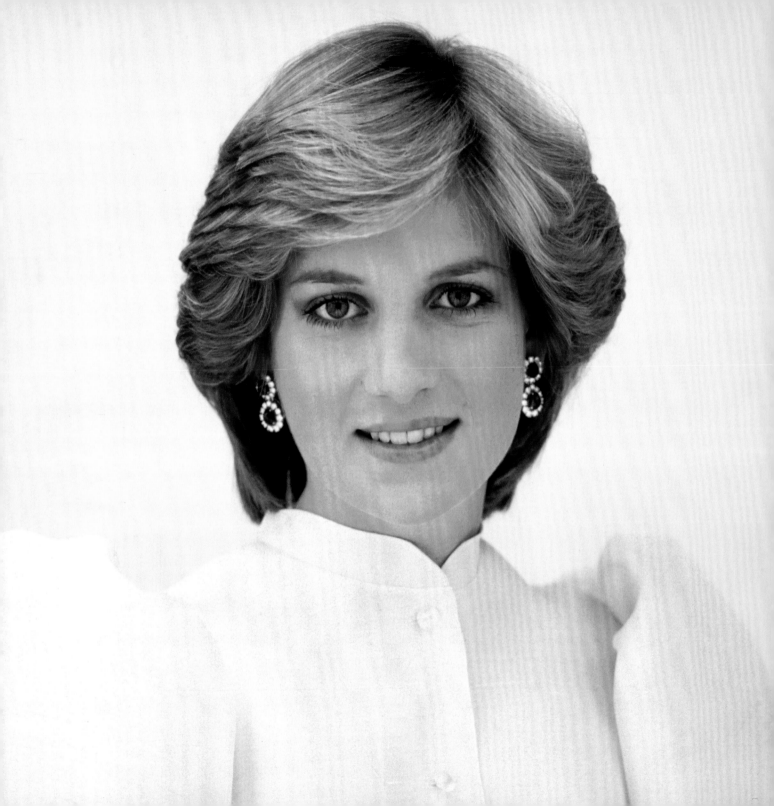

Twenty years after her death we miss her more than ever. In a world torn by conflict and blame, there's still a yawning gap, a public wound that continues to speak to her absence. So deep was the bond of compassion she forged with her admirers that her death in August 1997 at the age of 36 was a universal bereavement—one that no one who experienced those days will ever forget.

Diana was always a rebel. In 1994, at the end of a long string of tabloid revelations about the Prince and Princess of Wales's marriage difficulties, she was summoned, I am told, to a meeting with Queen Elizabeth and Prince Philip. It was clearly the first royal warning shot that she had better go quietly in what was her now inevitable divorce from Prince Charles. "If you don't behave, my girl," Prince Philip reportedly told her, "we'll take your title away."

Diana gave him a long, cool stare. "My title is a lot older than yours, Philip," the Earl Spencer's daughter replied.

She has been memorialized forever as the People's Princess. But first and foremost, Diana was a Spencer. Hers was a family more than 500 years old, with centuries of experience as power brokers to the throne. She was never intimidated by the royal family or afraid to take them on. In fact, the

OPPOSITE: An official portrait of Diana, taken in the summer of 1982, just before she became the Princess of Wales.

Hanoverian dynasty, whose descendants became the royal family of today, could not have attained their current heights without the powerful Spencers smoothing their ascent. It's one of the ironies of Diana's story that it took a girl from an impeccably aristocratic background to break the monarchy out of the crueler rigidities of class.

To understand why, you have to look to the experience that shaped her: her parents' divorce and the ensuing acrimony. When Diana was seven years old, her mother, Frances, left her father, then Viscount Althorp, for Peter Shand Kydd, the man she adored. Diana's two older sisters, Sarah and Jane, were already off at boarding school. Her younger brother, Charles, was too small to feel the pain—as Diana did—of their mother's departure. They watched as her car drove off through the gates of Park House, the Edwardian pile in the shadows of royal country residence Sandringham, where Diana was born and raised until the age of 14. Her pain was compounded by the treachery of Frances's mother, Baroness Fermoy, who sided with her father in the custody dispute: Diana's first taste of how power and patriarchy called the shots. When Frances returned to try to get access to her children, the butler shut the door of Park House in her face; they could not hear her screams to let her see them.

The rift between Diana's mother and grandmother planted in her a potent ambivalence towards the establishment. She saw how cruelly they sided with the power—her father—and how quickly her mother was on the out list, effectively banished from royal and high society circles. Diana would avenge her mother with the highest position society could offer; as future Queen of England, she believed she would have lifelong protection from rejection and divorce. When that did not turn out to be the case, the impact of her rebellion shook the monarchy to its core.

A frequent, erroneous press assumption at the time of Diana's engagement to Prince Charles was that her distinguished aristocratic background meant

familiarity with a grand, high-society world. In fact, Diana's childhood was limited in its circle and almost feral in its neglect. She spent most of her free time with the servants below stairs (one reason, perhaps, she could communicate so well with ordinary people). While her adored father spent hours in his study brooding morosely over his matrimonial discontents and dining in solitary grandeur alone, his children ate upstairs with the nanny.

Althorp House, the stately home in Northamptonshire that Johnny Spencer inherited from Albert Spencer, the seventh Earl Spencer, when Diana was in her early teens, was a lonely place. She rattled around the gilded halls, avoiding the company of her despised, social-climbing stepmother, Raine, whom her father had abruptly married in 1976, when Diana was 15, without forewarning his children. When he broke the news of his marriage, Diana slapped her father hard across the face, shouting, "That's from all of us, for hurting us."

Boarding school was not a place where Diana shone. The future Princess of Wales came from the last generation of uneducated upper-class girls. Plump, shy, and good-natured, with a love of ballet and swimming, she attended West Heath Girls' School, one of those intellectually dim ladies' academies that sent her off into the world at 16 with not a single educational qualification. At 19, she awaited the arrival of Mr. Wonderful while working as a children's nanny for an American businesswoman who lived in Belgrave Square.

Diana's lack of education was the source of lifelong feelings of intellectual inferiority. She made up for it with a keen strategic intelligence and a striking capacity for empathy that was noticeable even during her school days.

The senior classes at West Heath made annual volunteer visits to a nearby hospital for the mentally ill at Dartford. Most dreaded the visits to the bleak Victorian Gothic building, where patients awaited the girls in a gloomy, high-ceilinged hall for an afternoon of dancing. But not Diana. The hospital manager, Muriel Stevens, noted how Diana, unlike her classmates, was never

frightened by the grim, therapeutic scene. She brought a relaxed gaiety to the visits that enchanted the patients. And she devised a resourceful way of enhancing their pleasure on the dance floor. Many patients were in wheelchairs. Rather than push them from behind, the future princess faced the wheelchair and danced backwards on her long legs, gliding in a circuit with the chair so that she could maintain eye contact and human connection.

Diana always flowered in the presence of the disabled or the ill. It was a feeling that only expanded under the pressure of royal life and the disappointments of her marriage. During public engagements as the Princess of Wales, she would unerringly home in on the most needy, overlooked person in the room and gravitate to their side with a warmth that instantly engaged them. And later, as she came to understand the symbolic potency of gesture, she used her position to break taboos. In April 1987—a time when AIDS was still considered a pariah disease—she attended the opening of the first AIDS ward in the U.K. at the Middlesex Hospital. Her decision to shake hands, without gloves, with 12 male AIDS patients was critical in dispelling prejudice towards the ailment. And she never missed a chance to renew her outreach. Two years later, at a hospital in Harlem, New York, she spontaneously hugged an HIV-positive seven-year-old boy.

It's impossible to know what happiness Diana would have known—or who she would have become—if she had married someone other than the Prince of Wales. But it's also true that in 1977, when the naive 16-year-old first caught sight of the 29-year-old number one royal bachelor striding through a plowed field at an Althorp shooting party, there was no other rival for her heart. Charles Philip Arthur George, HRH Prince of Wales, Earl of Chester, Duke of Cornwall, Duke of Rothesay, Earl of Carrick, Baron Renfrew, Lord of the Isles, and Prince and Great Steward of Scotland, would be the only man for her.

A courtier's daughter, Diana was raised in the purlieus of Sandringham, where she often played with the young princes as a child. So it's hardly

surprising that the dashing eldest son of the Queen, who flew helicopters and dated a revolving cast of racy blondes, would be the pinup heartthrob on her bedroom wall. To Charles, however, Diana was the "jolly," "bouncy" younger sister of Sarah, whom he briefly dated. His future bride wasn't always a radiant beauty; she became one under the spotlight.

It was remarkable to watch this change over the years. At the time of her engagement, when she was 19, I was introduced to Diana at the American Embassy in London. She was wearing a pale blue gossamer-light organza dress and was agonizingly shy. No photograph, however, fully captured her exquisite peach complexion; her huge, limpid blue eyes; her imposing, slender height. Her small talk was gauche but enchanting. As she and Charles moved between the guests, she gazed up at the urbane, practiced Prince of Wales with starstruck adoration, hanging on his every word. Seventeen years later, in July 1997, when I lunched with her at the Four Seasons in New York shortly before her death, global celebrity had electrified her charisma. It was as if she had been elongated and grown taller still. Impeccably groomed, she strode across the dining room on three-inch heels, garbed in a dazzling emerald green Chanel suit, with all the confidence of a supermodel blonde who knew every eye was upon her.

———

What Diana always possessed, even at her youngest and shyest, was an uncanny grasp of how to play the press. She captured Charles with both empathy and artfulness. At a house party where they were thrown together in Sussex in 1980, she noted his sadness at the death of his beloved great-uncle Lord Mountbatten, recently murdered by the Irish Republican Army, and forged a connection. When, after a handful of dates and tabloid sightings, Charles left for a royal tour, she handled the paparazzi who stalked her with such deft charm and surefootedness that they—and the British public—fell

in love with her. And so—at least in his view of her as job applicant for future queen—did the Prince of Wales.

Diana did not know until it was too late that the wedding of the century at St. Paul's Cathedral, watched by a global TV audience of 750 million people in 1981, was a charade. (As her sister Sarah put it, "your face is on the tea towels now.") She thought her union with Charles was a love match. The callousness of the royals (and the entire circle around Prince Charles) was that they never let her in on the truth: Her romantic dream was, at its core, an arranged marriage. The match was cynically contrived by the Queen Mother, who had singled her out as one of the last available virgins from the right family. It was boosted by Diana's lethal grandmother, Baroness Fermoy, and eagerly endorsed by the Queen and Prince Philip, who were desperate for Charles to produce an heir and feared his persistent passion for his married mistress, Camilla Parker Bowles, had become more of a threat than an extended dalliance. Charles—like his great-uncle King Edward VIII, who had abdicated his throne for the married, twice-divorced American Wallis Simpson—was showing signs that he would never give Camilla up. And Diana at 19, a demure charmer with no past and the right pedigree, was the most appropriate target to fit the matrimonial bill.

With the benefit of 20 years of hindsight, the wrong perpetrated on the young Diana by the crown seems unconscionable. They gaslighted her, and they isolated her. Compounding the isolation was the fact that her elder sister Jane was married to the Queen's assistant private secretary, Robert Fellowes, and therefore deep inside the royal circle. Her other sister, Sarah, never really forgave Diana for being the one to capture Charles.

It was soon after the engagement that the young bride-to-be increasingly sensed the unwelcome presence of Camilla Parker Bowles. The older woman always seemed to know details of the betrothed couple's plans before anyone else, and Diana saw the private gifts she exchanged with her fiancé. She

picked up on Camilla's knowing questions. And aboard the royal yacht while on her honeymoon with Charles, she overheard the secret calls and felt the constant presence of an unseen rival. Charles lied to her about her fears and reinforced her feelings of inadequacy. Her deep sense of being unloved and unsupported led to bulimia, instability, and a neurotic desire for attention. The royals and their close aides made it clear they found her tiresome.

Worse, they were jealous. The wedding was hardly over before Charles began to smart from what court insiders referred to as the "upstage problem." It is another of the great ironies of Diana's life that everyone was in love with her except her husband. Her physical transformation from charming, unthreatening "Sloane Ranger" to international celebrity bombshell was watched by the world in rapt fascination. But not by Prince Charles. In him, Diana's metamorphosis produced the opposite effect. The more star power she radiated, the more overlooked he felt. On their first trip as husband and wife to Wales, the mayor of Brecon recalled how the royal couple worked both sides of the rope line as thousands thronged the route to Caernarvon Castle. But the crowd only called out, "Di! Di!"—and when they saw Prince Charles approach, they groaned, "Oh no!"

This was a first for Charles. He was, after all, HRH the Prince of Wales, the supposed star of the national show, and his new status wounded his amour propre. The Queen was none too happy about it either. Her sister, Princess Margaret, seethed that when Diana sat in a glass coach with Princess Anne in the procession accompanying the Queen to the State Opening of Parliament in November 1981, the only press coverage the next day was of Diana's new updo.

While the royal family should have been jubilant that Diana was reinventing the image of the monarchy, court insiders, alert to the jealousies and displaced in their old routines, were dedicated to suppressing her. Unlike Kate Middleton 15 years later, when the lessons of Diana's tragedy had been fully absorbed, the

20-year-old Princess of Wales was offered little guidance or protection as she tried to navigate the uncharted waters of royal celebrity.

And her unhappiness was seeping into the press. In a 1985 *Vanity Fair* cover story, I broke the news of the behind-the-scenes storms in the Wales's marriage. It was clear to me from talking to their friends that Charles and Diana were hopelessly ill-matched—intellectually, sexually, and socially— and were having epic offstage rows. He was a very old 36, and she a very young 24. Charles was reverting more and more to mystics, environmental gurus, and his mistress. The more he spurned his wife, the more Diana sought the reassurance of media adulation. The royal couple's vehement denials of discord—and their decision to go on BBC TV and refute my piece—only confirmed to palace watchers that the stories were true. The following month, the Waleses came to Washington and put on a royal command performance at a White House dinner thrown by the Reagans. It was an iconic moment in the Dynasty Di mythomania. Wearing a midnight blue velvet off-the-shoulder Victor Edelstein gown and her signature pearl choker, Diana took to the floor after dinner to dance with John Travolta, bringing a Hollywood dimension to the glittering fable of the shy girl who married a dashing prince.

But the pictures flashed around the world didn't change the real story. As Diana's global stardom increased, so did her unhappiness. Five years later, after affairs with her bodyguard Barry Mannakee and her handsome riding instructor James Hewitt, Diana was determined to smash the fairy tale that had trapped her. Her decision to break every royal taboo and go public with her marital misery was as breathtaking in its impudence as it was flawless in its cunning.

Over the course of six months in 1991, Diana's friend Dr. James Colthurst bicycled to Kensington Palace with a tape recorder hidden in the basket. There, he conducted interviews with her and cycled off again with her stunning revelations—of Charles's infidelity, of her own struggles with bulimia, of the callousness of the royals—and delivered the smoking tapes to tabloid

journalist Andrew Morton. What he published the next year as *Diana: Her True Story* was essentially her memoir, written in his name.

The first Charles learned of it was on the morning of Sunday, June 7, 1992, as he sat across the breakfast table from Diana at Highgrove House, their family's home. As his wife pecked at her toast, he unfurled his carefully folded copy of the *Sunday Times* and saw an excerpt of Morton's book. The headline: "Diana Driven to Five Suicide Bids by 'Uncaring' Charles."

The storm, when it broke, did more than make the teacups dance. It blew through the House of Windsor and every assumption of establishment consensus: discretion, deference, and mutual protection. It ended the system of structural infidelity. It blew up the facade of royal respectability. It rent the veil of sovereign privacy. No wonder Prince Philip referred to Diana, raised in a family that had always protected and served the crown, as "the fifth columnist."

The marriage was now, in essence, over. Diana would have always been a beautiful, compassionate woman—but her tribulations and her position gave her the incentive to become extraordinary. Pain made her luminous.

She sublimated her lovelessness into acts of humanitarian leadership, boosting the efforts of the Red Cross, advocating for others with eating disorders, and ministering to the homeless, to orphans, to AIDS patients, and to the disabled. Charles's circle mocked her "saintly" acts as self-promotion—but none who experienced Diana's natural wells of kindness ever forgot how it felt. Her compassion was real, and the realization of how much her outreach could matter to those she touched gave her a purpose that now propelled her life.

And no one in the royal family could deny her devotion as a mother, validated today by the easy, natural self-assuredness of her sons. Diana fought for William and Harry to have as normal a childhood as was possible for a member of the Royal Family, wrapping the boys in the warmth and joy that both she and Prince Charles had been deprived of growing up.

One of the many sadnesses of Diana's story is why she was in Paris at all that fateful August in 1997. Life had been better after a divorce from Charles that was acutely bitter. There had been the sensation of her appearance on the BBC in the now legendary television interview with Martin Bashir, where she revealed to a shocked nation the full extent of her husband's abandonment—"there were three of us in this marriage"—admitted to infidelity herself (many by this time), and dared to imply that the Queen was out of touch. In other eras, such words would have been considered an act of treason that would have sent her to the Tower of London. For Diana, it was the brilliant curtain-raiser to obtaining, after four years of separation in August 1996, the divorce settlement she felt she deserved from the famously stingy royals.

In the year that followed her freedom from her marriage to Charles, Diana had never looked more beautiful nor achieved more meaningful impact. In January 1997, on a humanitarian trip to Luanda, the capital of Angola, she was horrified by the sight of the disabled and amputees on the streets who had been victims of unexploded land mines. Her commitment to abolish these deadly relics of war was not, as her enemies tried to characterize it, a publicity stunt. The land mine cause drew forth everything that was best about her in the service of a mission that was heartrending, underpublicized, and controversial. In Huambo, Angola, in perhaps the finest moment of her life, Diana exhibited all the bravery and recklessness she had used to defy the royal family when she walked through a field of unexploded land mines. And when the press complained they hadn't got the shot they wanted, she did it again.

At the time of her death, Diana also achieved the beginnings of a truce with Prince Charles. As she aged, the divorced couple found that they had more in common than they had realized: their causes, their sense of public duty, their pride in the way their boys were turning out. She was getting an education at last—not from books, but from the troubles of the world. No longer

a callow girl, she was becoming the woman with whom Prince Charles could, without Camilla's presence, have shared the partnership his parents had enjoyed. Sometimes Charles even dropped by her apartment in Kensington Palace for tea.

But love, or the lack of it, would always be Diana's primal wound. Since the summer of 1995, she had found deep fulfillment in an affair with Pakistani heart surgeon Hasnat Khan. But as a conservative Muslim, he could not win the approval of his family to marry her—nor was it realistic to imagine that, as a dedicated doctor, he could tolerate the searing tabloid exposure that came with being the man in Diana's life.

The end of their affair in 1997 left her empty and vulnerable. In June, she came to New York for the Christie's auction of all her glittering gowns to benefit AIDS and cancer patients. It was the ultimate statement of her desire to leave her "fairy tale" past behind. But over lunch at the Four Seasons, she was wistful as she spoke to me—not of her success as a humanitarian leader, but of the loneliness of the summer ahead. In August the boys would go, as they did every year, to stay with their father and their grandparents at Balmoral. The world assumed, she told me, that everyone would vie to invite her as their guest. But hosting her came at a price of lost privacy that most of her friends did not want to pay. At this point, a fortress was needed to keep the press out. The tabloids even scavenged the garbage, looking for tidbits on her private life.

In another of the great ironies of Diana's fate, the invitation to cruise the south of France by yacht with her new admirer Dodi Al Fayed primarily meant safety. "He has all the toys," she told her friends, meaning the accoutrements—the private plane, the car and driver, the servants and bodyguards belonging to his tycoon father, Mohammed Al Fayed (who also owned Harrods and the Ritz Hotel in Paris)—that were required to protect her. Since her divorce, in typical willfulness, Diana had rejected the Palace's offer of a bodyguard, fearing he would spy on her.

At six minutes past midnight on August 31, 1997, guided only by Dodi's chaotic plan to elude the Paris paparazzi, he and the most famous woman in the world descended in the service elevator of the Ritz, exited the hotel, and slid into the backseat of a black Mercedes. The car, driven by the drunk-acting head of security, Henri Paul, who had been recalled unexpectedly from his night off, took off at breakneck speed into the Pont de l'Alma tunnel.

As Diana heard the ascending buzz of the paparazzi's motorbikes behind, did she think of her two young sons asleep in a Scottish castle? Did she wonder what she was doing here beside a feckless playboy whose values were the opposite of her own, pursued again by the wolves of the tabloid press? Tragically, the woman who had walked through a field of unexploded land mines did not feel the need to buckle on a seat belt.

The crash and the frantic, unsuccessful attempts to save her at the Pitié-Salpêtrière hospital were followed by "the Great Sorrow"—a wave of pain that swept the British Isles and the world as a numb and disbelieving public learned of Diana's loss. Today the courtiers who work at Buckingham Palace refer to the upsurge of anger against the Queen's refusal to return from her Scottish palace at Balmoral as "the Revolution"—because it nearly was. Ironically, it was perhaps the only time in the monarch's life when duty yielded to family. The Queen felt her bereft grandsons needed her more than the British public did.

It could be argued that only the imagery of Diana's monumental funeral saved the monarchy in these extraordinary days. The moving sight of the four royal men—Prince Philip, Prince Charles, the two young princes, William and Harry—along with her brother, Charles, Earl Spencer, walking behind her casket as it wound its way past St. James's Palace; the silent, weeping crowds; the representatives of the princess's charities processing somberly behind; the velvet silence in the heart of grief inside Westminster Abbey before Elton John sang his unforgettable anthem.

It was as if Diana's death had allowed England's stiff upper lip to tremble at last, and acknowledge that it was no longer a hierarchical, class-bound society imprisoned by the cruel expectations of conformity it had shown the princess during her life. In the days before the funeral, you could see it in the miraculously new feeling of the grieving crowd: gay couples, interracial couples, the old and the young, the disabled and the fit, the rehabbed and the paroled pouring from buses and trains into London's streets, impelled by love and loss. Diana had achieved global power in an era before Twitter, before Facebook, before YouTube were there to amplify it.

In 2007, I asked then prime minister Tony Blair what, if anything, Diana's life had signified. A new way to be royal? "No," he replied without hesitation. "A new way to be British."

And so she did. As her exhausted funeral procession reached Althorp, where the casket would be rowed out to its burial place on an island in the lake, her brother declared, "Diana is home."

He could not have been more wrong. Althorp had not been home to Diana for a long time. Perhaps it never was. It represented what she had suffered through so much to escape. Twenty years after her death, it is time to acknowledge what we have learned from the example of a woman of privilege who showed the world the importance of humanity: Diana, Princess of Wales.

TINA BROWN
*Tina Brown is an award-winning journalist and editor.*
*She is the author of* The Diana Chronicles *(2007),*
*a best-selling biography of the Princess of Wales.*

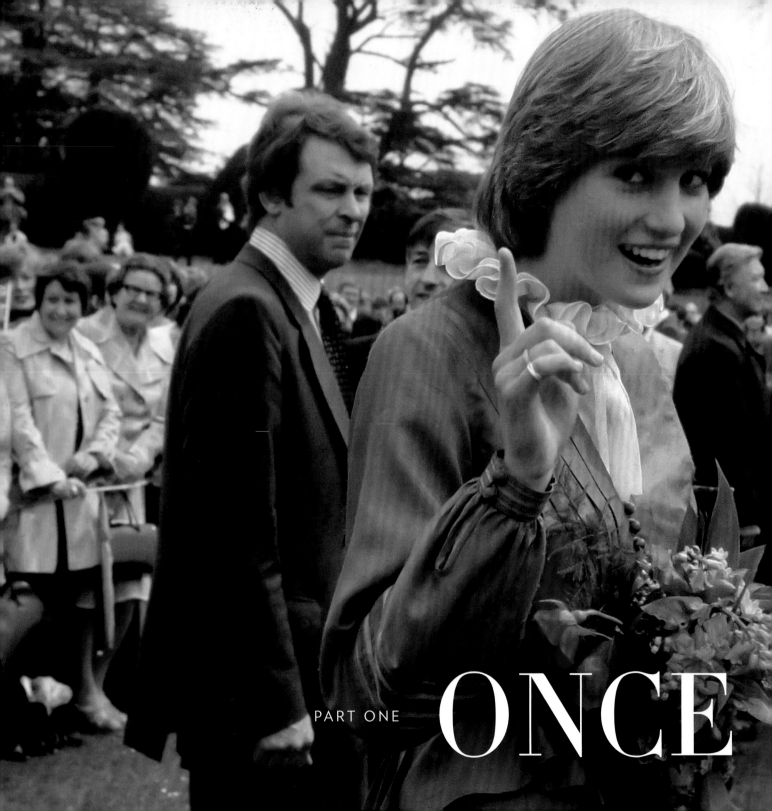

PART ONE ONCE

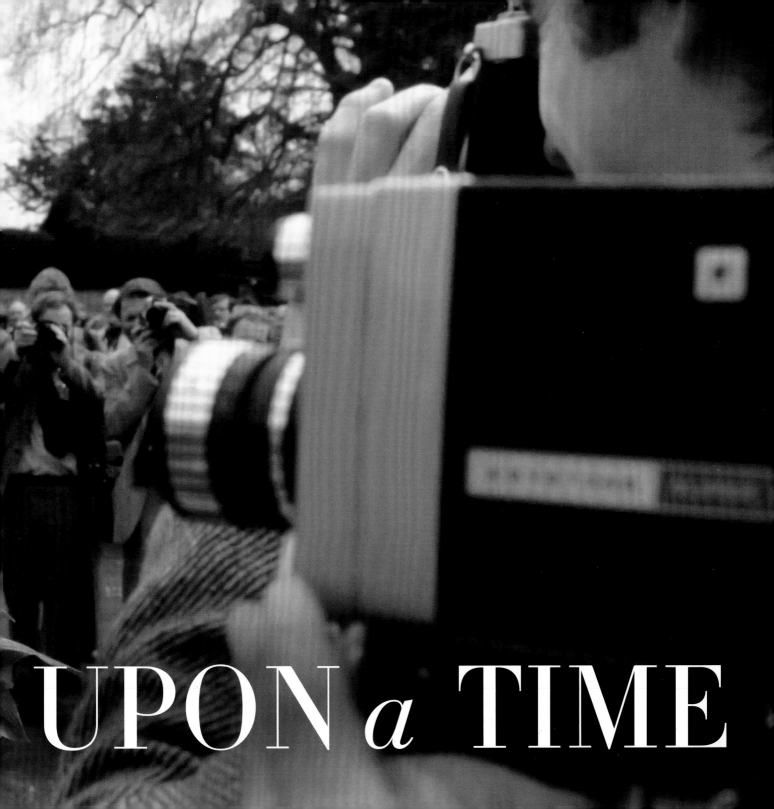

# UPON *a* TIME

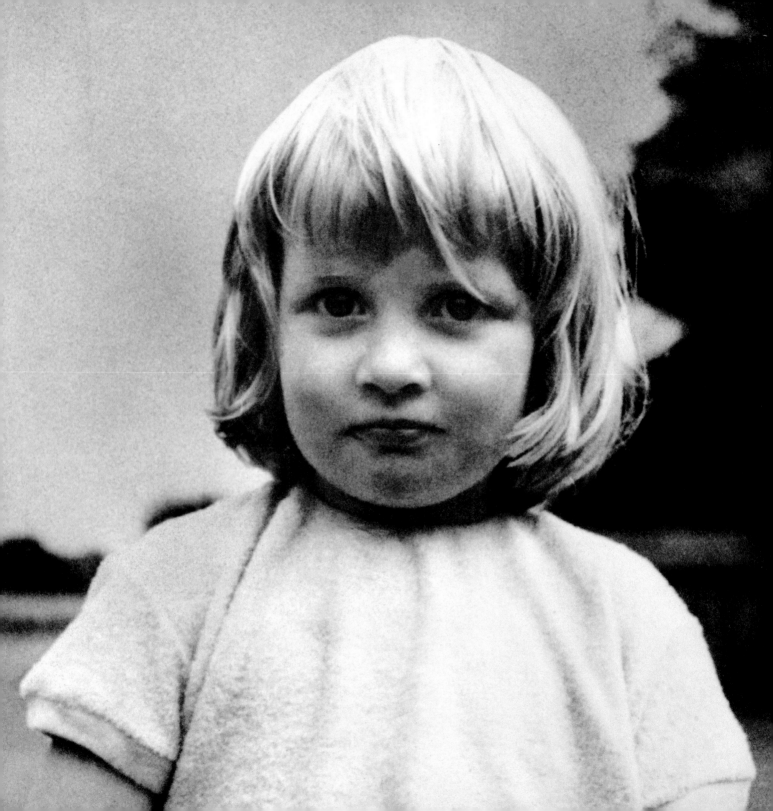

Before she was the Princess of Wales, Diana Frances Spencer was a shy, lively, and good-hearted girl from the English countryside. But she was also never far from royalty. Born into British aristocracy on July 1, 1961, Diana was the fourth child of Frances and Edward John "Johnnie" Althorp. The Spencer family had long been intertwined with the crown: In 1954, Queen Elizabeth II attended Frances and Johnnie's wedding at Westminster Abbey. And Diana's childhood home was located on the Queen's property at Sandringham, a favorite vacation retreat of the royal family. Not just the girl next door, Diana—the 11th cousin to Charles, Prince of Wales—ran in the same social circles as her future husband. Her destiny seemed written from birth.

But Diana's childhood was far from idyllic. Her parents' marriage fell apart before she was 10 years old. Diana's upper-class education left her undereducated. Boarding school stressed manners and general happiness over academics. Diana didn't excel as a student, but she did find success in swimming and music. More important, she made lifelong friends who would become integral as a loyal inner circle when she became Princess of Wales.

That story began in November 1977, when Diana met Charles. Charles, who was more than 12 years Diana's senior, was attracted to the young ingenue's high spirits; the Queen was impressed by her breeding. A romance would slowly develop under the watchful eyes of both the media and the royal family. And when their engagement was announced in February 1981, the world was ready.

---

OPPOSITE: As a chubby-cheeked three-year-old, Diana stares into the camera. *1964*

PREVIOUS PAGES: Diana visits the Broadlands—the royal family's Romsey, Hampshire, estate. *May 1981*

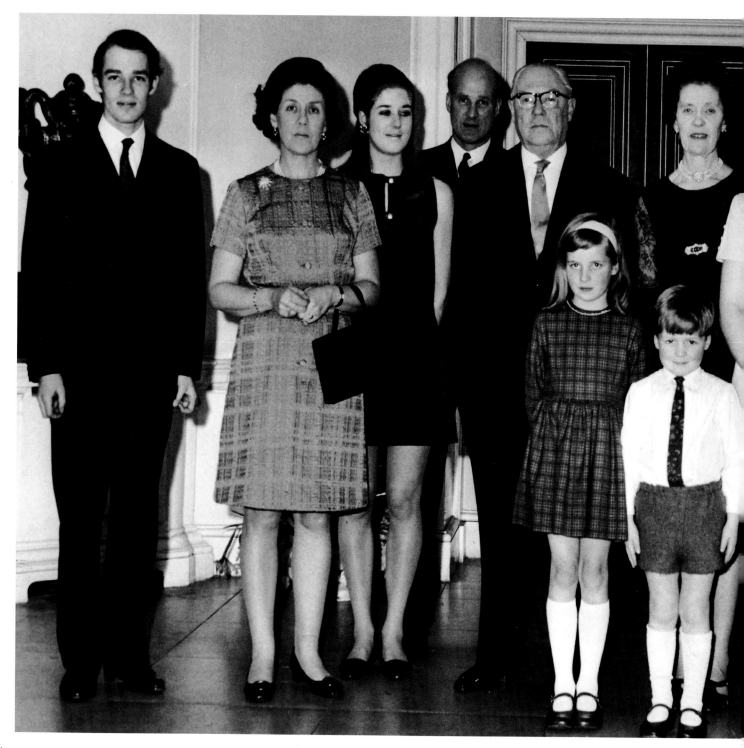

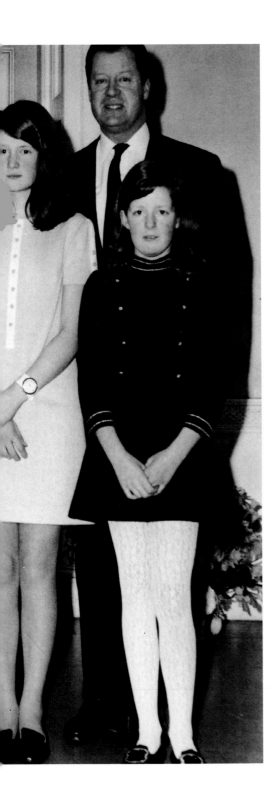

LEFT: A family portrait taken on the 50th wedding anniversary of Diana's paternal grandparents, the Earl and Countess Spencer (center). Diana in knee-high socks stands in front, beside her younger brother, Charles. Her older sisters, Sarah and Jane, stand in front of their father, Johnnie Althorp (back right). *March 1969*

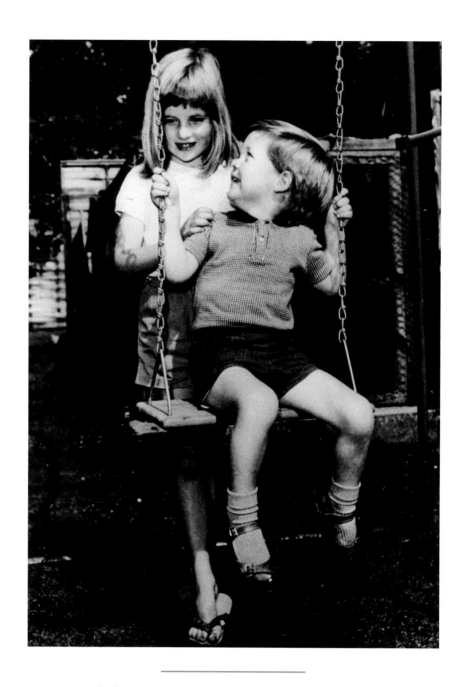

ABOVE: Charles Spencer, now Viscount Althorp, smiles as his six-year-old
sister pushes him on a swing at Park House, their childhood home. *1967*

OPPOSITE: Diana holds a croquet mallet during a game at Itchenor, West Sussex,
in 1970. An athletic child, she excelled at diving and swimming during her teenage years.

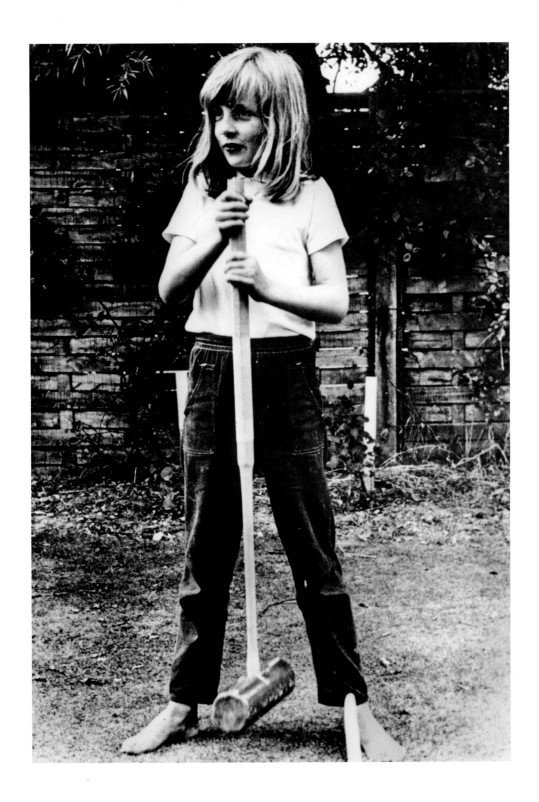

RIGHT: A snapshot from a family album shows Diana and her little brother, Charles, in Berkshire, England, in 1968.

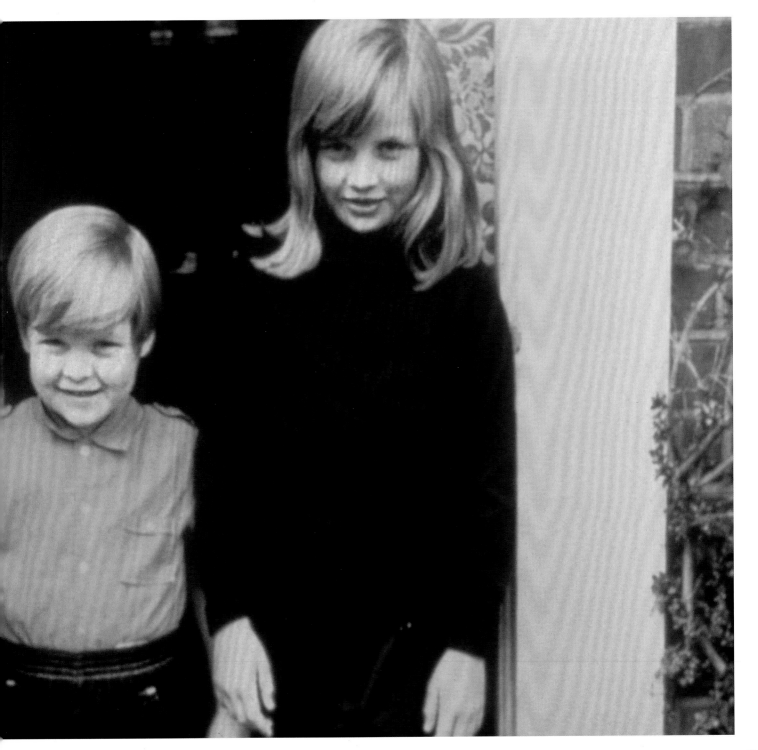

## CLASSIC DIANA

D iana grew up surrounded by dogs, cats, hamsters, rabbits, and horses. "She loved animals when she was a child," her mother said. "She loved everything that was small and furry or had feathers." Diana learned to ride horses before she was four, but after she broke her arm in a riding accident, her love faded. Still, her empathy for all living creatures would be a hallmark of her life. Here she holds her pet guinea pig during a 1972 pet show in Sandringham. She brought her guinea pig to her first boarding school, Riddlesworth Hall, where she was made head of "Pets' Corner," where the students' pets were housed.

FOLLOWING PAGES: Diana, shown (far right) with her father and siblings at Park House in the early 1970s. The family moved to the Spencer estate in 1975 when her father became the eighth Earl Spencer, after the death of his father.

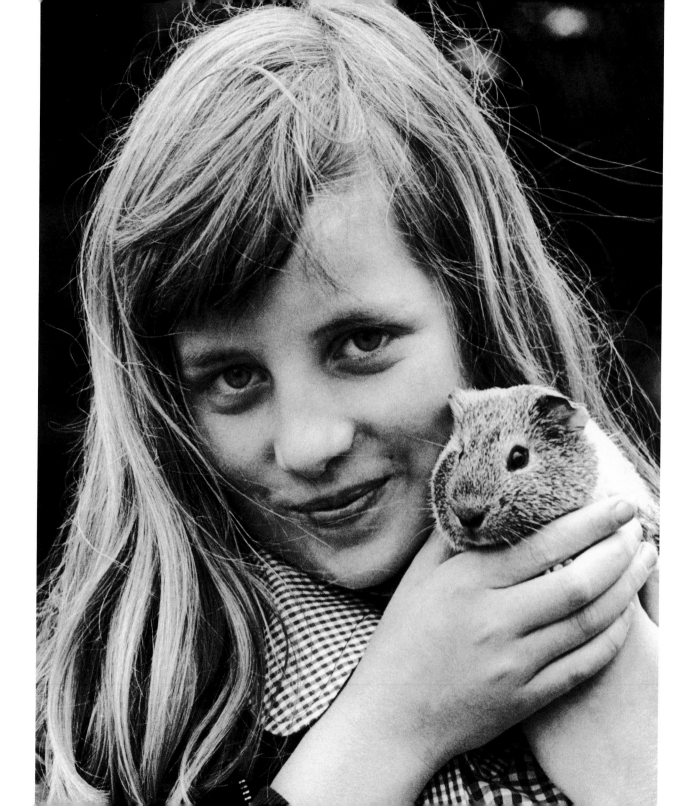

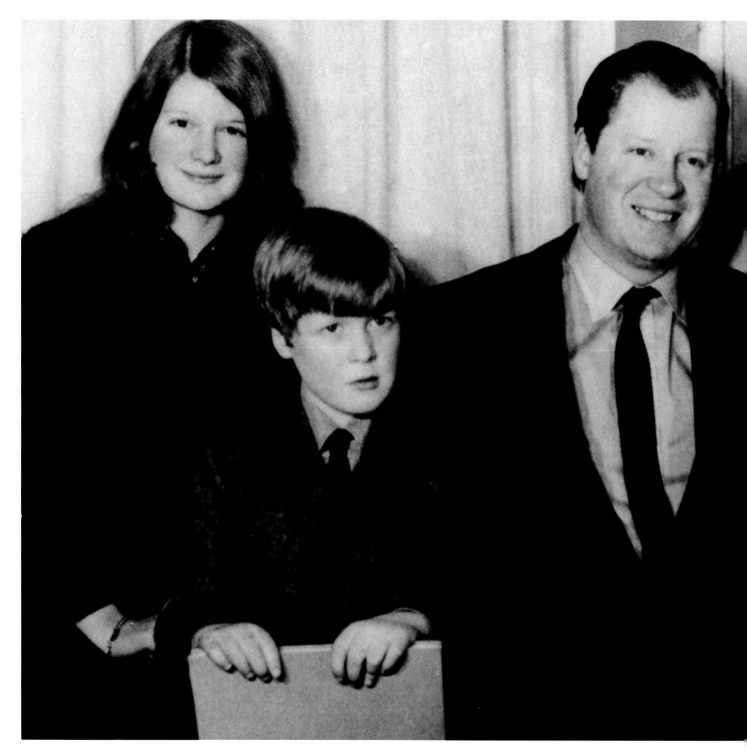

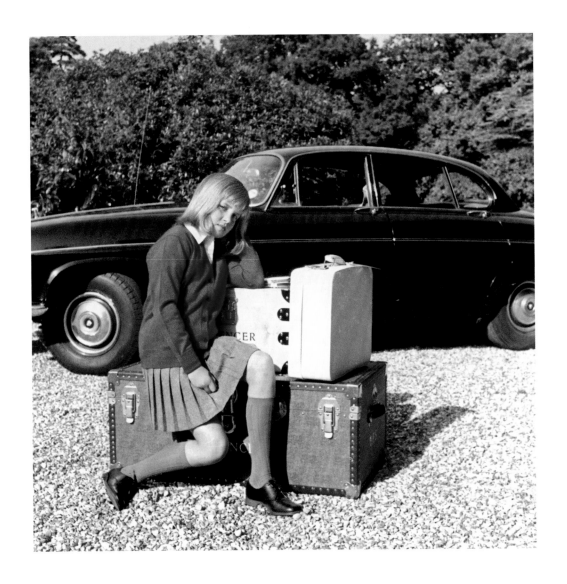

Diana sits on her suitcases as she prepares to go to boarding school
at Riddlesworth Hall in the fall of 1970. Distraught over the separation from
her home, she told her father, "If you love me, you won't leave me here."

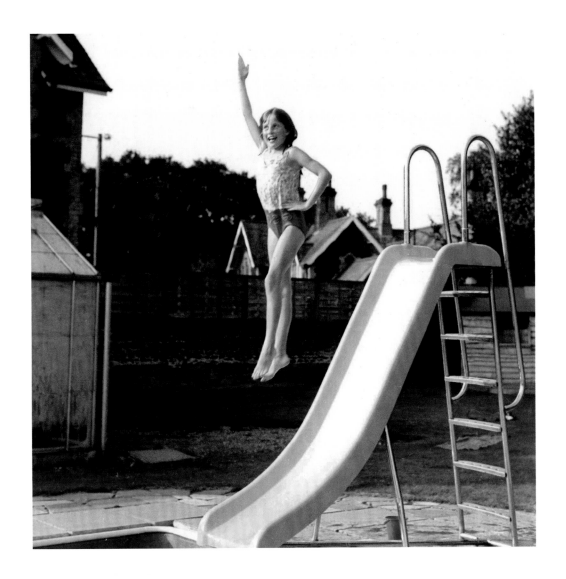

Always poised, even when jumping off a slide into the family's
pool at Park House, a youthful Diana shows off her fun side. Her red
swimming badges can be seen at the bottom of her bathing suit.

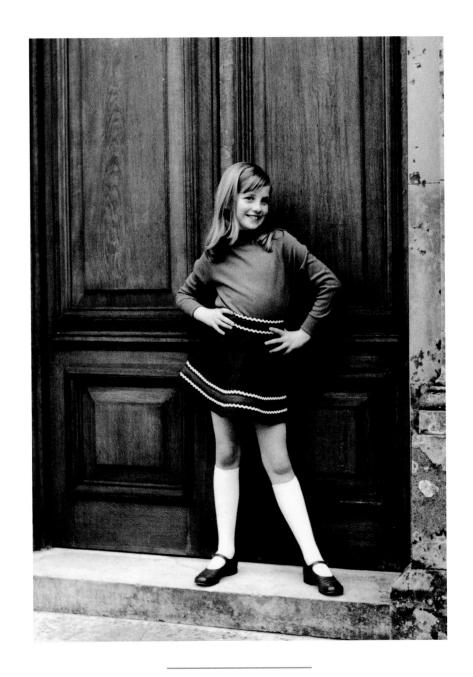

ABOVE: A photo from a private family album dated 1967–69 shows Diana posing cheekily as a young girl. Obviously a natural in front of the camera, she also had a keen sense of fashion from an early age.

OPPOSITE: A pensive mood crosses Diana's face in a photo from a family album. Known as shy and quiet in her youth, possibly because of tensions between her parents, Diana gained confidence in adulthood.

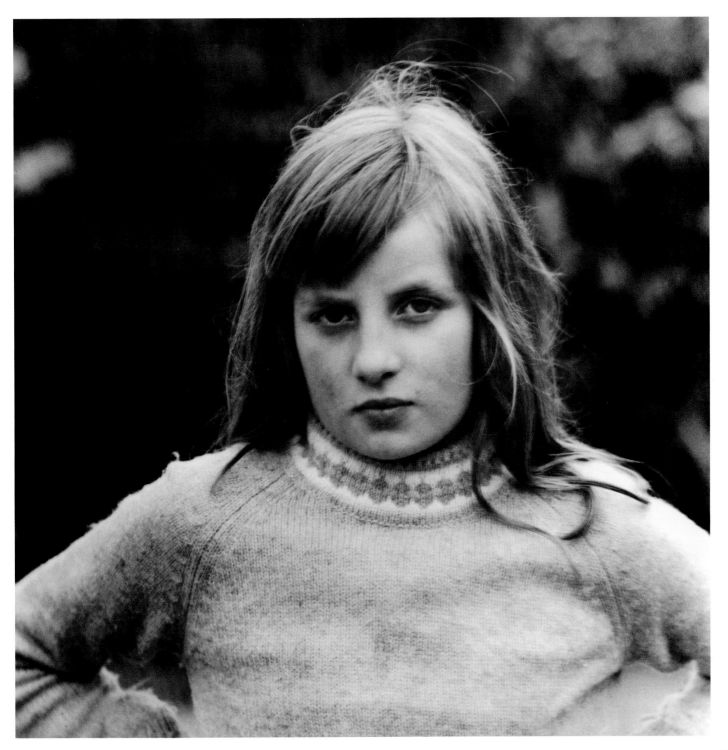

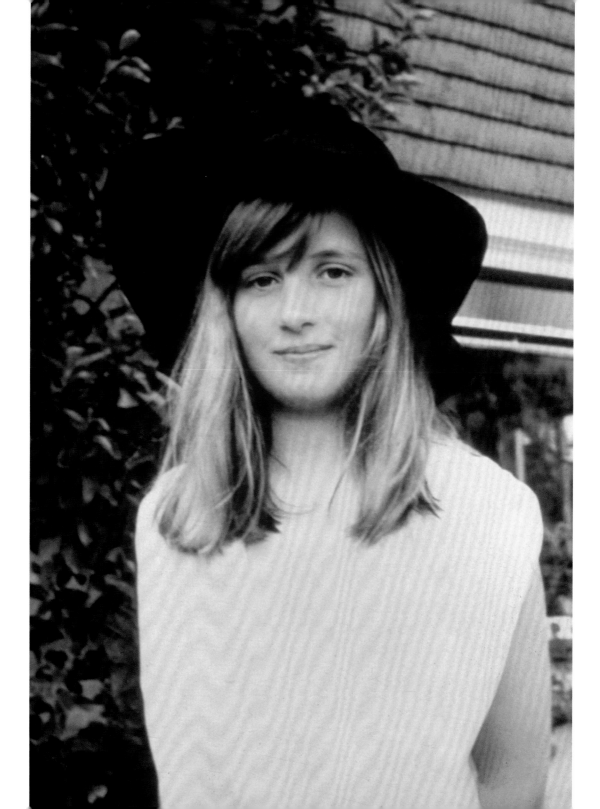

"From her childhood, Diana had had the feeling that she was destined for something special, that she would *be* somebody. There never was a chance that she would have, as people have surmised, settled down and led the life of a country gentleman's wife, walking the dogs and rearing a handful of children. Her sense of destiny was far too strong."

—SARAH BRADFORD,

AS REMEMBERED IN *THE PEOPLE'S PRINCESS*

OPPOSITE: During a 1971 family holiday in Itchenor, West Sussex, Diana sports a black felt hat.

RIGHT: Diana's pet Shetland pony Soufflé moves in to nuzzle her 14-year-old owner. Diana kept the pony at her mother and stepfather's house on the Isle of Seil, off Scotland's west coast, which she visited during vacations. *1974*

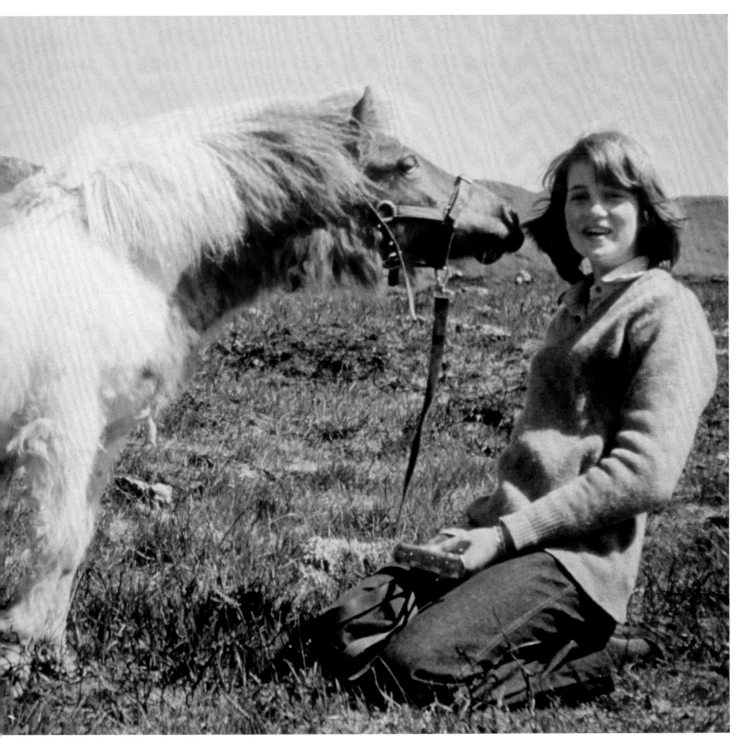

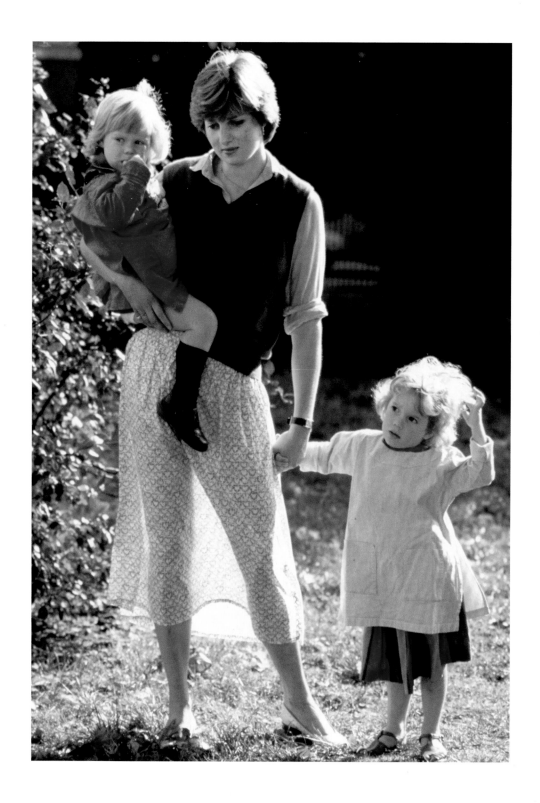

## CLASSIC DIANA

A love of children was evident early in Diana's life, and she chose to make a career of it as she entered adulthood. After moving to London in the late 1970s, she took jobs as a nanny for a wealthy family and as a part-time assistant at a kindergarten. Here, she stands with two young children in her care at London's Young England Kindergarten. Diana turned 20 the same month she married Prince Charles, and became a mother less than a year later. By all accounts, Lady Di was an involved and devoted mother, giving her sons a joyful childhood.

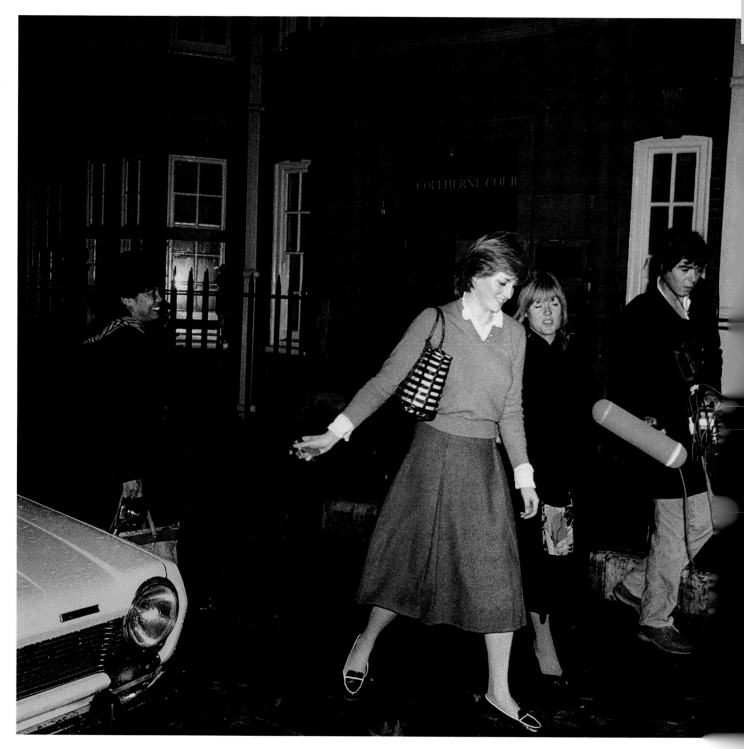

LEFT: Reporters flank Diana and a friend in front of her flat, which she shared with three roommates in Coleherne Court in November 1980. She once said her days in that apartment were among the happiest of her life. But after being designated as the soon-to-be princess, Diana had to quickly become accustomed to the press surrounding her home and whereabouts.

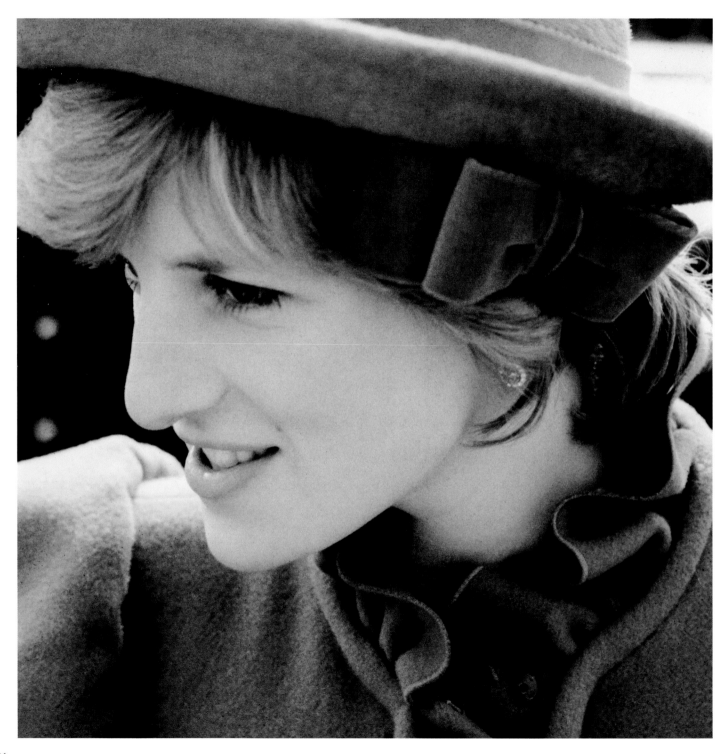

LEFT: Reporters flank Diana and a friend in front of her flat, which she shared with three roommates in Coleherne Court in November 1980. She once said her days in that apartment were among the happiest of her life. But after being designated as the soon-to-be princess, Diana had to quickly become accustomed to the press surrounding her home and whereabouts.

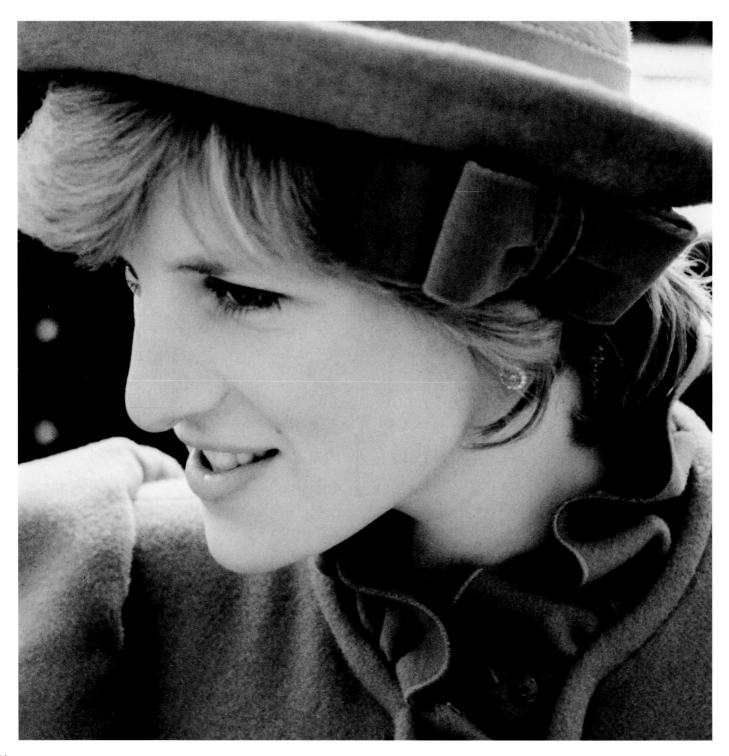

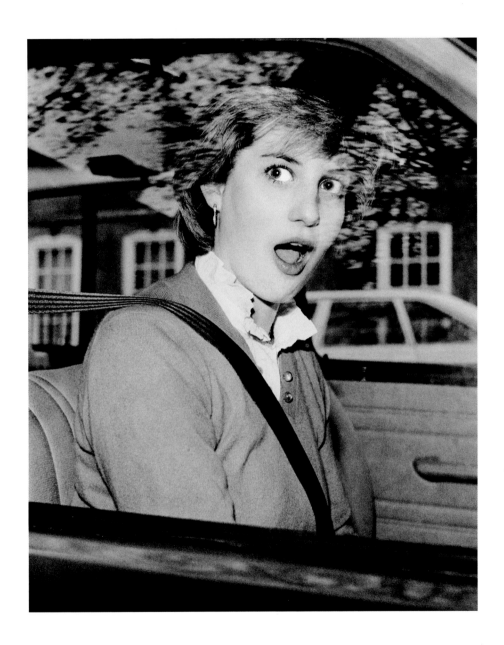

ABOVE: After her courtship with Prince Charles began, Diana become instant fodder for the British paparazzi. Here, she's startled by their attention after her car stalls outside of her London flat. *November 1980*

OPPOSITE: The world instantly became fascinated with the young, soon-to-be princess. And news outlets began publishing photographs of Diana daily. *1980*

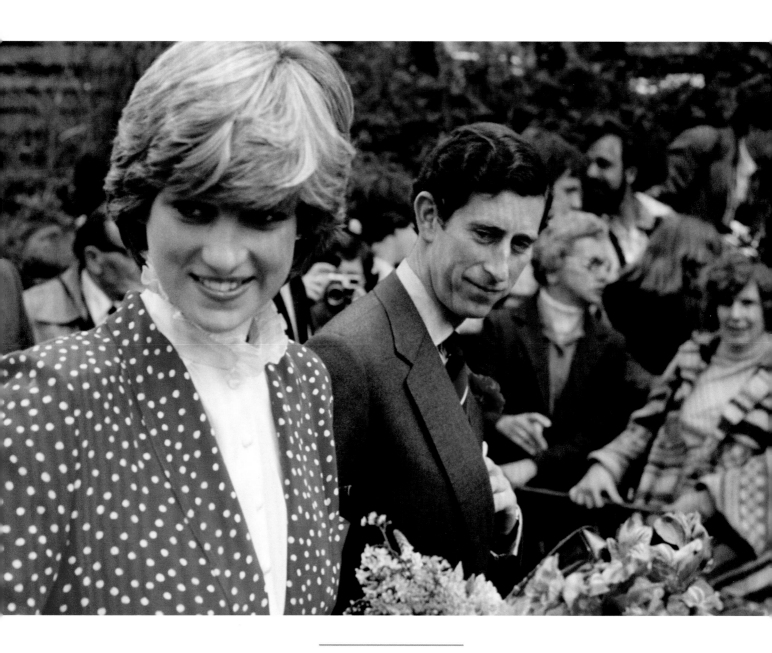

Diana wears a Jasper Conran suit as she visits Tetbury with Prince Charles
in May 1981, shortly after their engagement. Two aspects of her new life were
already apparent at that time: an ease with the press and rapt public attention.

At the age of 19, you always think you are prepared for everything, and you think you have the knowledge of just what's coming ahead. That's youth for you. But although I was daunted at the prospect [of marrying into the royal family] at the time, I felt I had the support of my husband-to-be . . . I desperately wanted it to work, I desperately loved my husband and I wanted to share everything together and I thought we were a great team."

—DIANA SPENCER,

IN BBC'S 1995 *PANORAMA* INTERVIEW WITH MARTIN BASHIR

RIGHT: It is smiles all around in March 1981, after the Queen's Privy Council approved the crown prince's wedding to Lady Diana. Announcing the royal engagement from Buckingham Palace, the Queen said, "We are all delighted."

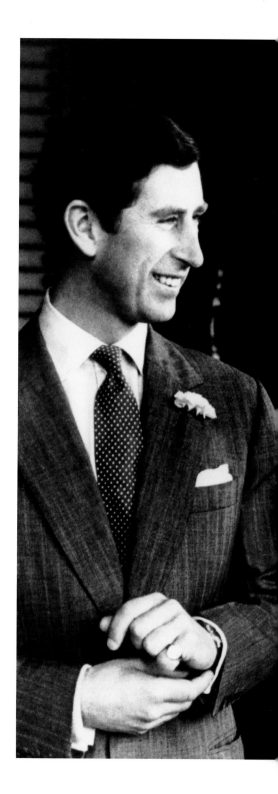

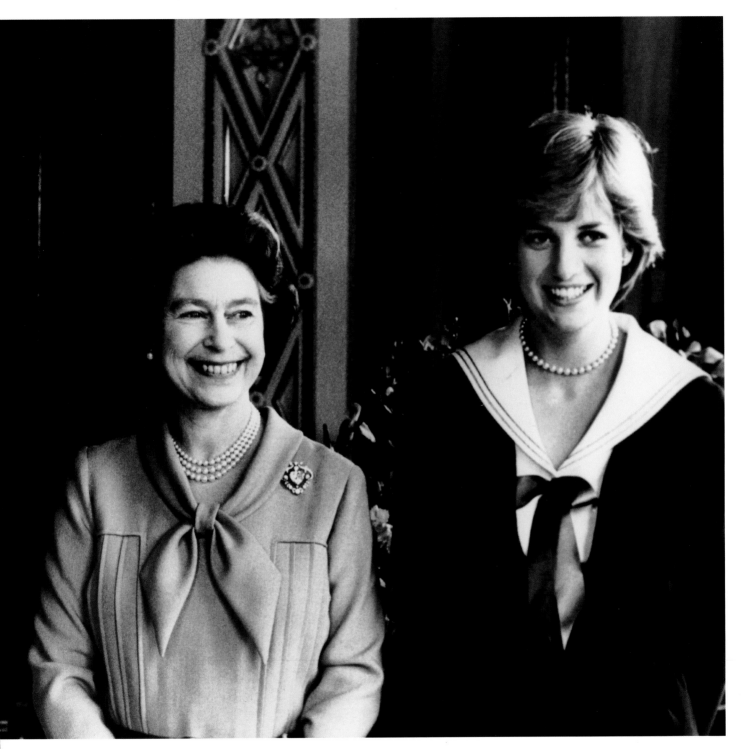

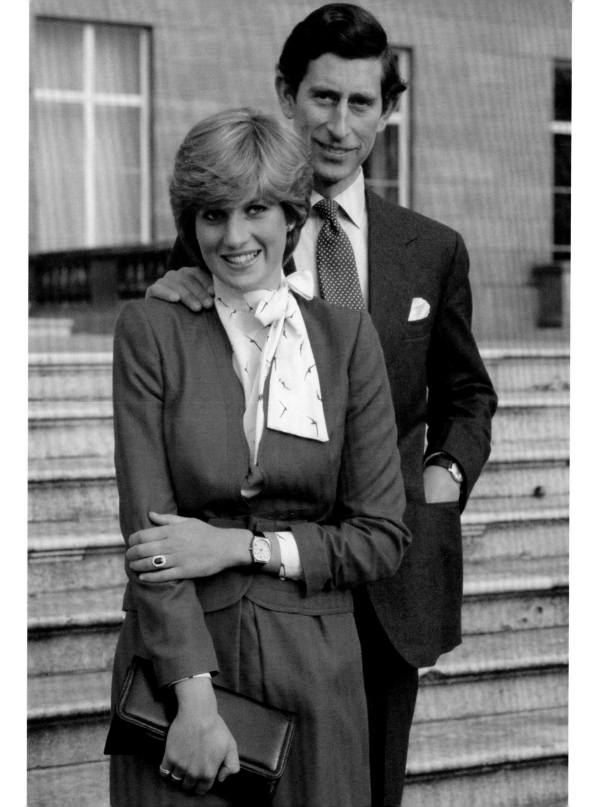

"She seemed like the perfect bride for Prince Charles. She was young, attractive, she had the right background."

—RICHARD KAY,

ROYAL CORRESPONDENT, IN *MY MOTHER DIANA*

OPPOSITE: Announcing their engagement, the happy couple poses at Buckingham Palace on February 24, 1981. The 19-year-old Diana displays her sapphire wedding ring, complemented by a matching blazer and skirt.

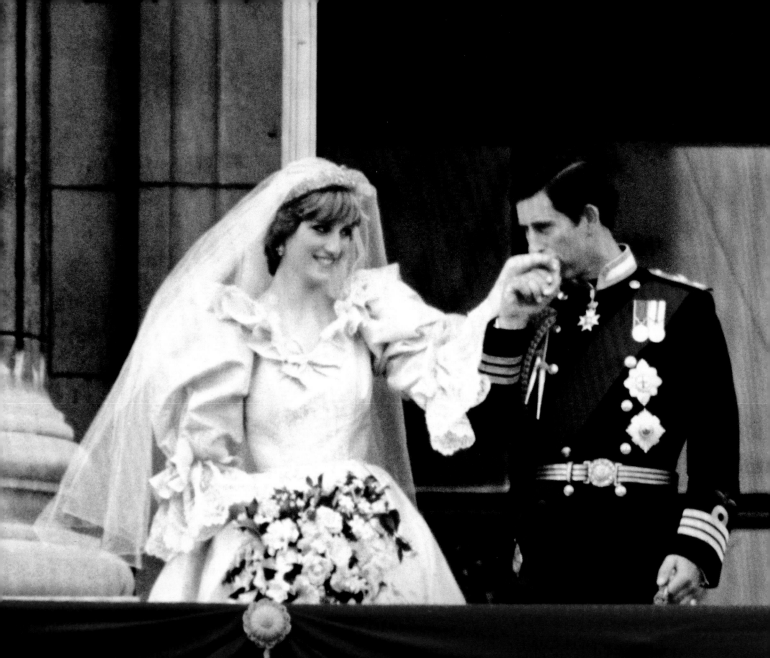

PART TWO INSIDE

FAIRY TALE

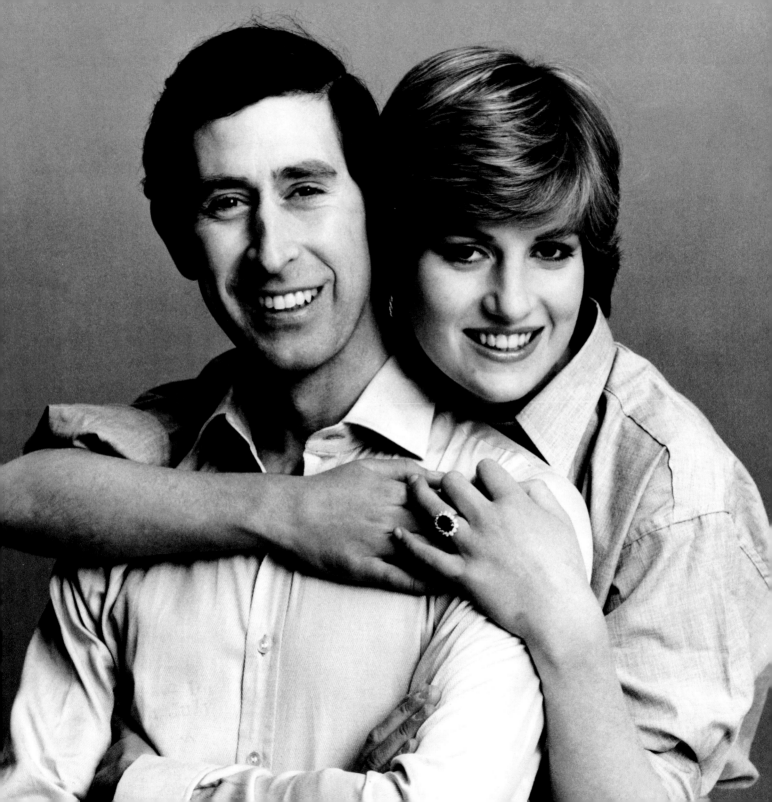

O n Wednesday, July 29, 1981, 750 million people tuned in to watch Prince Charles and his bride, Diana Spencer, exchange their wedding vows on live television. Hundreds of thousands more took to London's streets in hopes of glimpsing the golden couple. Upon their arrival, Robert Runcie, the Archbishop of Canterbury, pronounced, "Here is the stuff of which fairy tales are made."

Runcie was right, in a sense; the wedding was a fairy tale that captured the imagination and hopes of royal-watchers, romantics, and the world at large. But there was a darker edge, with Diana's prewedding jitters foreshadowing deeper questions about the foundation of her marriage and life in the royal household.

The wedding, however, was magnificent. And as viewers watched the royal marriage unfold, they fell in love with the princess's charm, charitable spirit, and beauty. It was a sweeping love affair—but one focused outward, on the princess and the public. And it would have far-reaching implications for the royal family.

To the public, they were a happy couple, completed by the arrival of William and Harry. But it wasn't long before the cracks in the marriage began to show. Both Diana and Charles became subjects of rumored affairs that fueled the tabloids' front-page headlines. Diana later admitted to bouts of depression, bulimia, and loneliness within her marriage. In 1992 the Palace announced Charles and Diana's separation. Four years later, on August 28, 1996, the Prince and Princess of Wales officially divorced.

---

OPPOSITE: Days before their wedding, Prince Charles and Lady Di pose together. *July 1981*

PREVIOUS PAGES: The bride and groom emerge on the balcony at Buckingham Palace to greet the 600,000 onlookers gathered on the streets of London. The image of Prince Charles kissing the hand of his princess became immortalized as "the kiss." *July 29, 1981*

# CLASSIC DIANA

Throughout her short life, Diana brought comfort to many, as she was always ready to console anyone in distress and not shy about reaching across class divides. Genuine in its nature, this impulse—which was later seen during her visits to homeless shelters and AIDS clinics around the world—was first noticed by the public on her wedding day. Here, with the Queen looking on, Diana comforts her former student, five-year-old Clementine Hambro, who had tripped and hurt her head. The photo (opposite) of Diana tending to the young flower girl became an iconic example of the princess's compassion.

FOLLOWING PAGES: Diana's wedding dress, designed by David and Elizabeth Emanuel, was an ivory taffeta and antique lace gown with sequins and pearls. The 25-foot-long train trailed behind her as she made her way into St. Paul's Cathedral. She and Prince Charles wed in front of a congregation of 3,500 people.

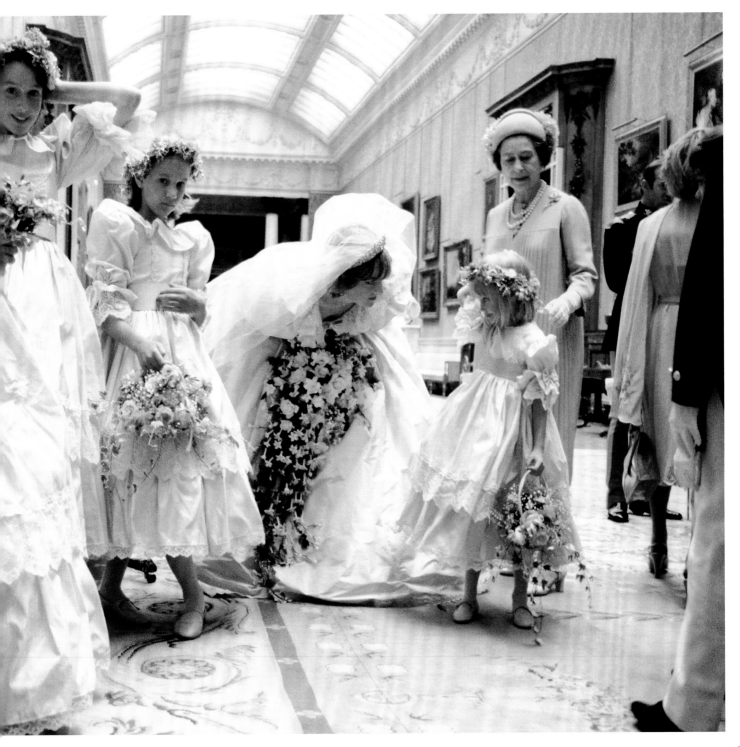

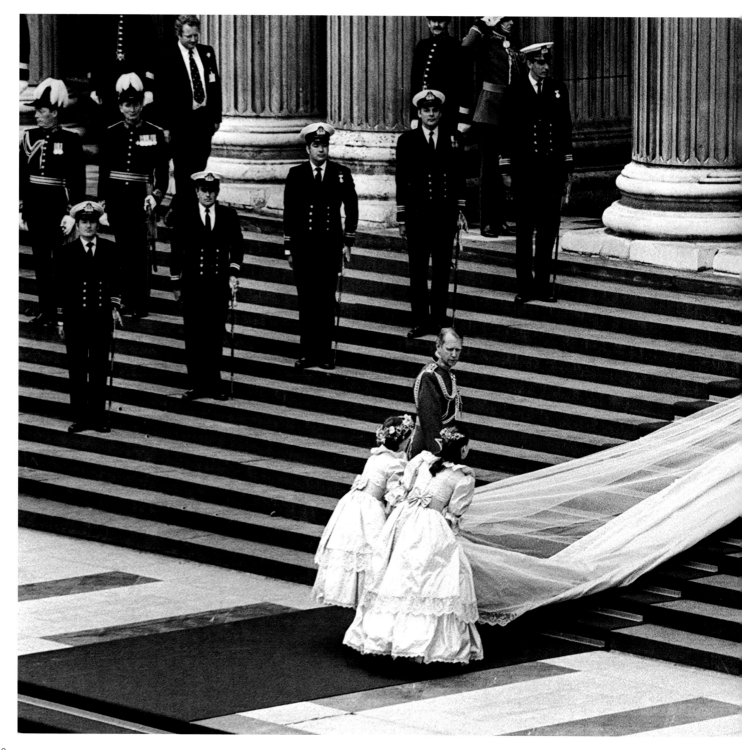

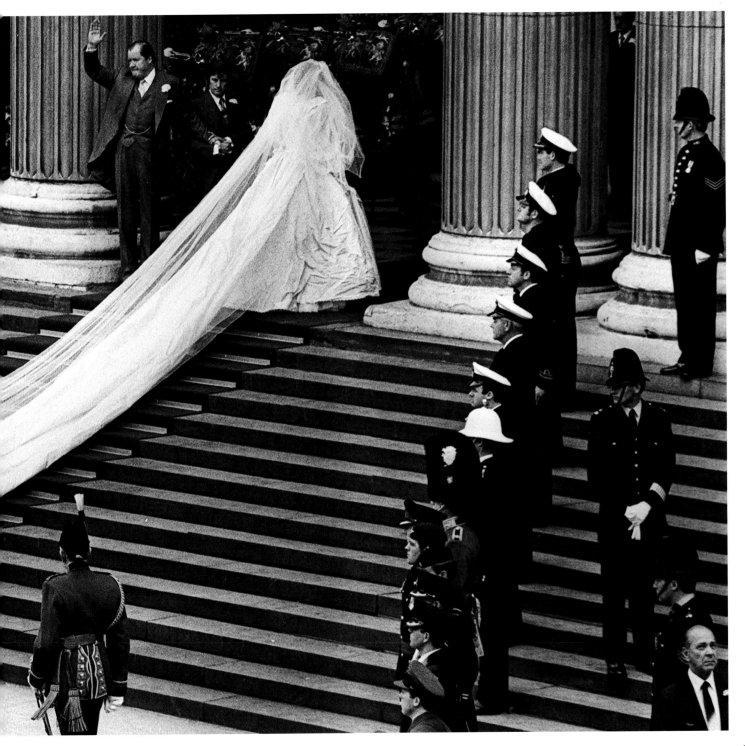

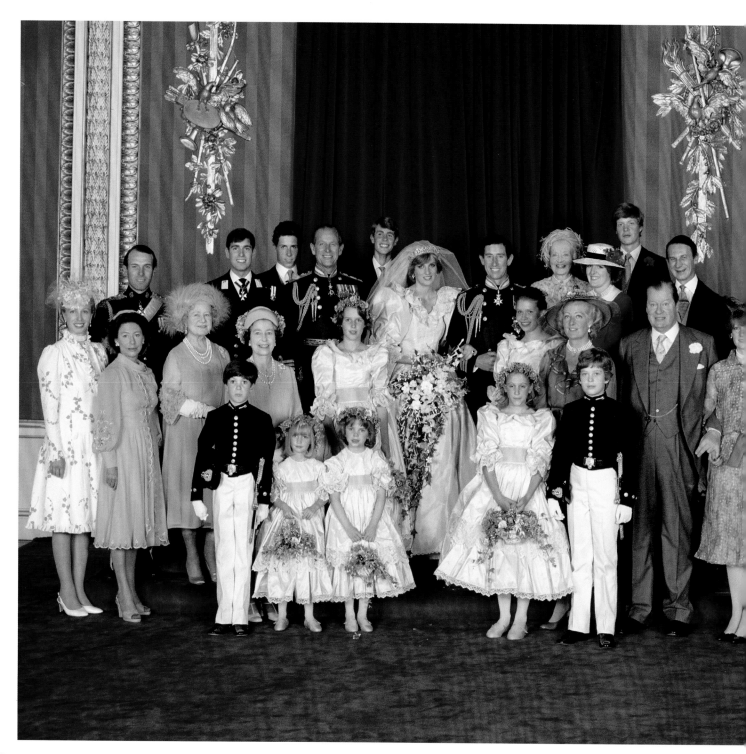

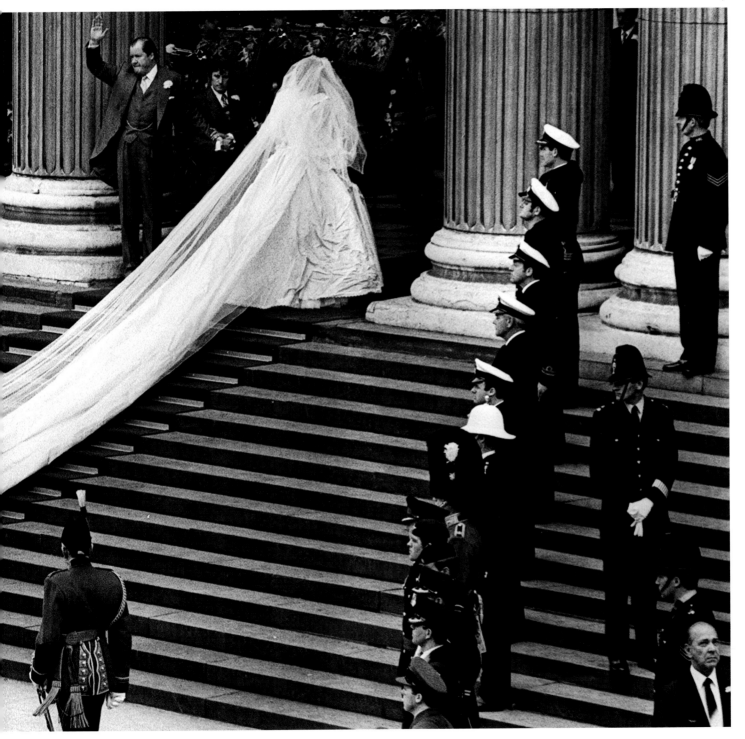

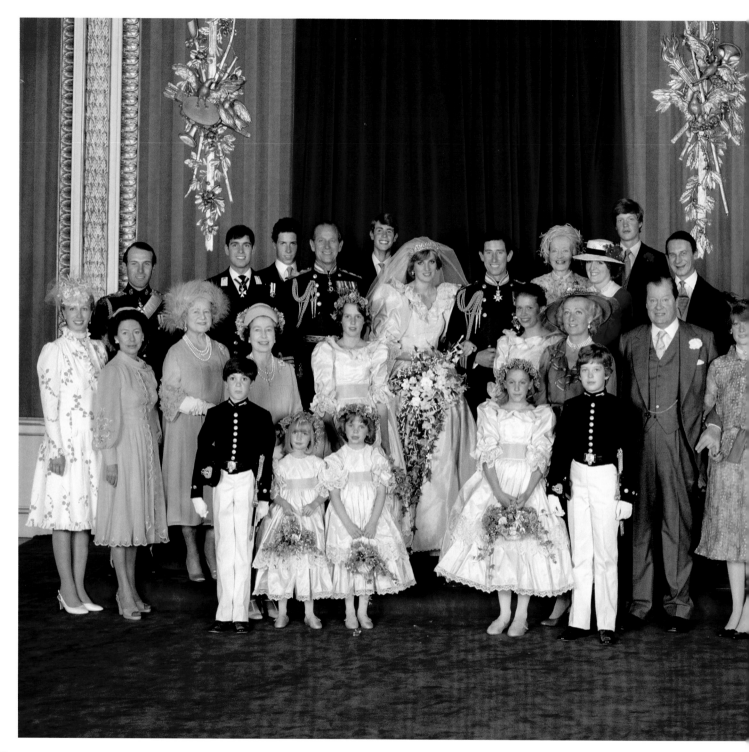

LEFT: A royal wedding portrait in the Throne Room at Buckingham Palace. The former Lady Diana Spencer, now the Princess of Wales, stands at center with her prince. The Queen (wearing a blue dress) stands next to the Queen Mother (in a teal dress) on the left. Diana's mother, Frances (in green), is next to her father, Earl Spencer, on the right. The wedding brought together two families and ended the speculation over the bachelorhood of Prince Charles.

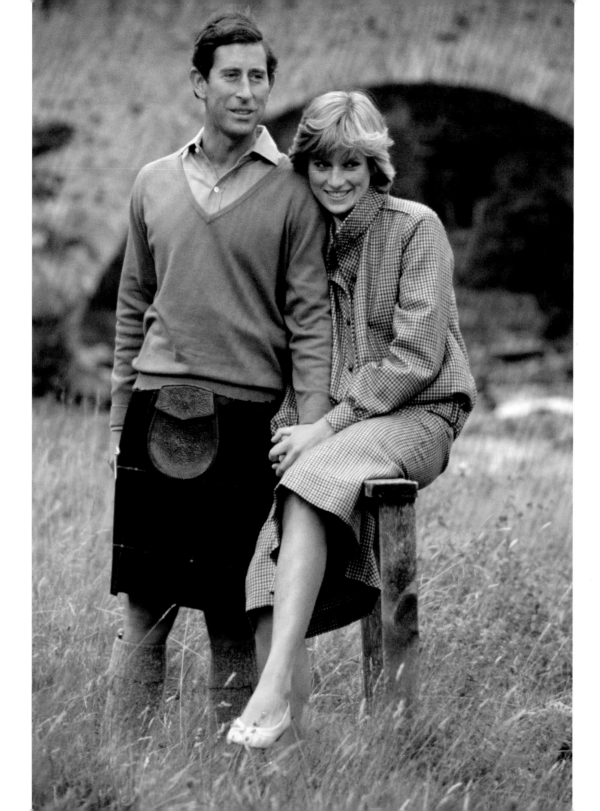

"I didn't have any idea what I let myself in for. One day, I was going to work on a Number 9 bus, and the next, I was a princess."

—PRINCESS DIANA

OPPOSITE: The prince and princess honeymooned at the royal family's Scottish home, Balmoral Castle, by the River Dee. Enjoying newlywed bliss, they were photographed holding hands on the riverbank. *August 1981*

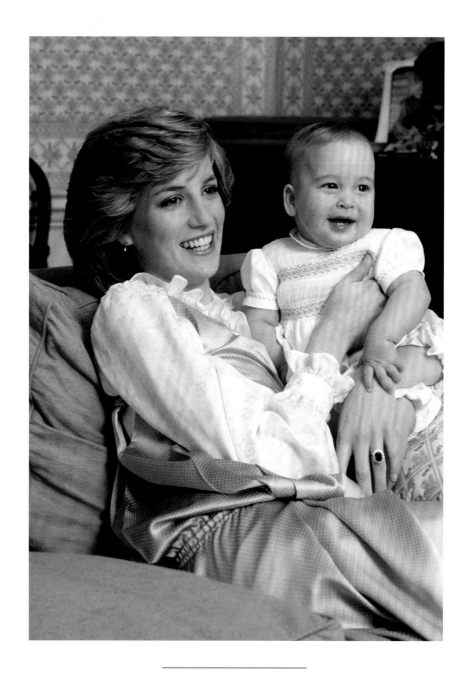

ABOVE: Diana holds eight-month-old William at Kensington Palace. The announcement of the baby prince was made with the traditional handwritten notice on a gate at Buckingham Palace. *February 1983*

OPPOSITE: In December 1983, the couple hold their 18-month-old son, William, as he stands on a bench in a garden at Kensington Palace.

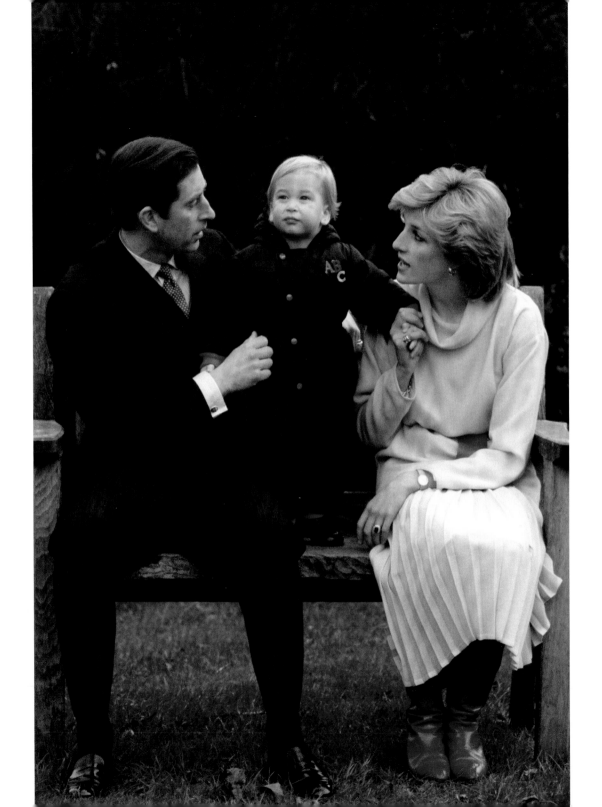

"Well maybe I was the first person ever to be in this family who ever had a depression or was ever openly tearful. And obviously that was daunting, because if you've never seen it before, how do you support it?"

—PRINCESS DIANA,

IN BBC'S 1995 *PANORAMA* INTERVIEW WITH MARTIN BASHIR

RIGHT: Diana—in the diamond and pearl tiara given to her by Queen Elizabeth on her wedding day—attends a banquet in New Zealand in April 1983 with Prince Charles, the first state trip after their marriage. The trip, which included a stop in Australia, where 100,000 people came out to see them, was the start of what would become known as Di-mania.

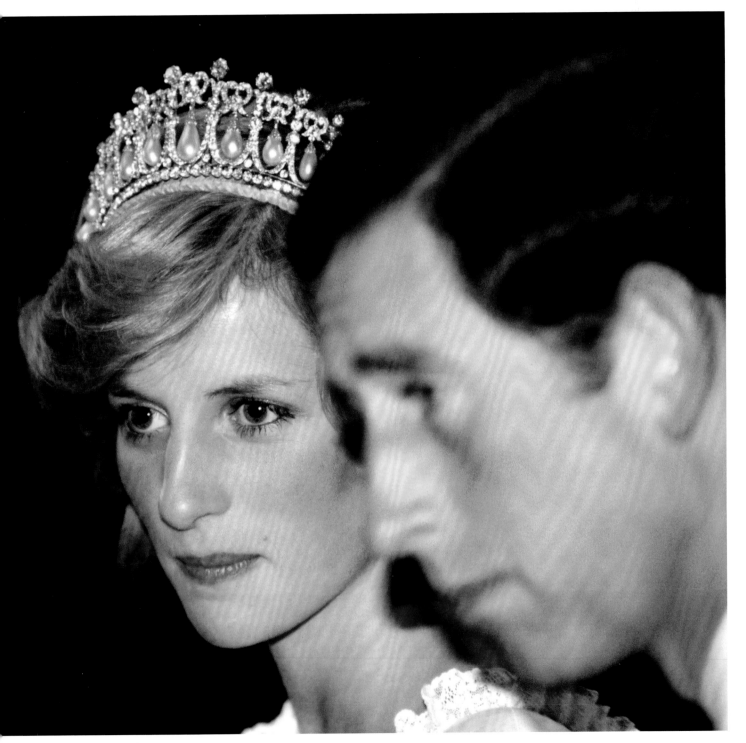

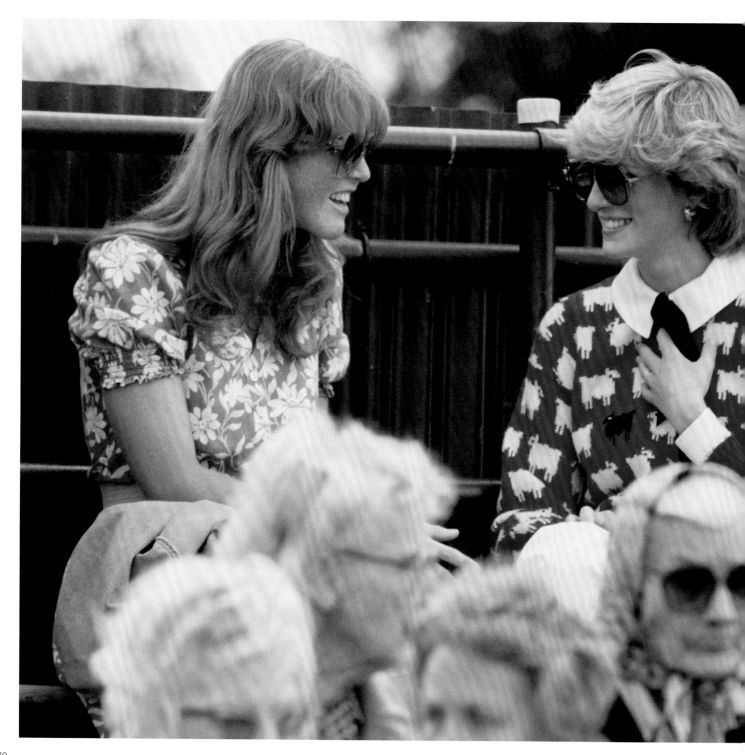

LEFT: Diana shares a laugh with Sarah Ferguson at the Guards Polo Club in Windsor. In the summer of 1986, Sarah would marry Prince Andrew, Charles's younger brother—a marriage that would bring its own set of fireworks to the royal family. *June 1983*

"I liked her compassion, that she was so much fun . . . She made you completely feel at ease . . . There wasn't a stiffness or an awkwardness, which there can be sometimes with other members of the royal family, because you're so aware of protocol. She was funny. She was . . . compassionate."

—ELTON JOHN,

IN A 2002 INTERVIEW ON CNN'S *LARRY KING LIVE*

OPPOSITE: As her star grew, Diana's admirers became taken with the princess's eye for fashion, as well as her charm. Here, she dresses in plaid at the Braemar Highland Games in Scotland. *September 1982*

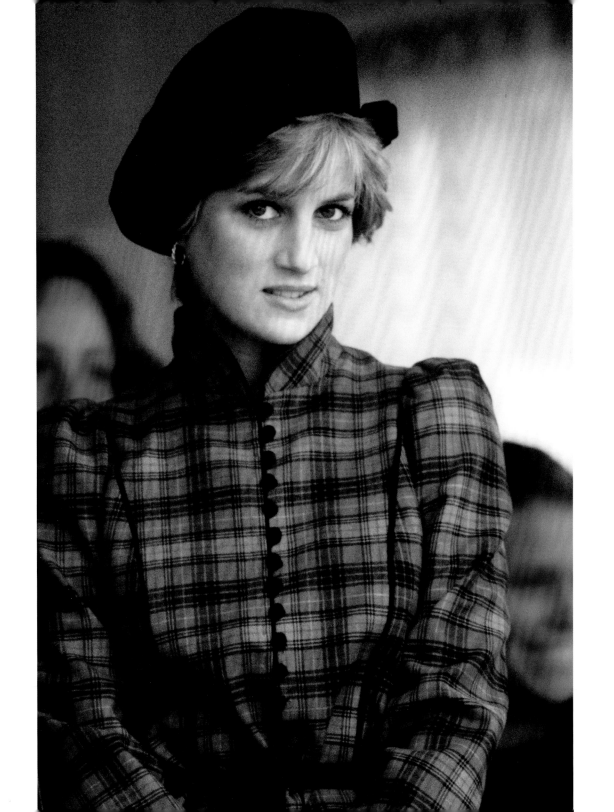

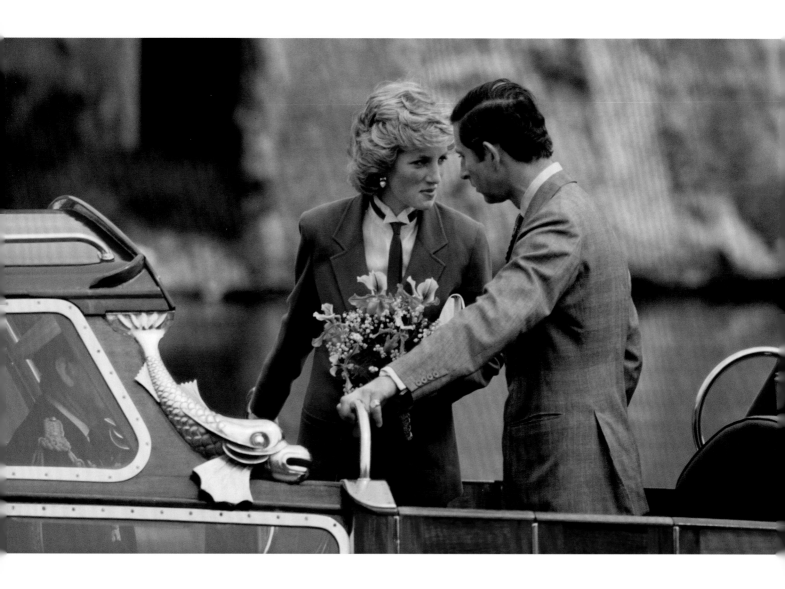

ABOVE: During an official visit to Italy in April 1985, the prince and princess
huddle in private conversation on a boat in the Tuscan port city of Livorno.

OPPOSITE: Diana and Charles share a kiss after a charity polo match on June 29, 1985.
With the media following their moves—and moods—there was no end to the speculation
about the state of their marriage.

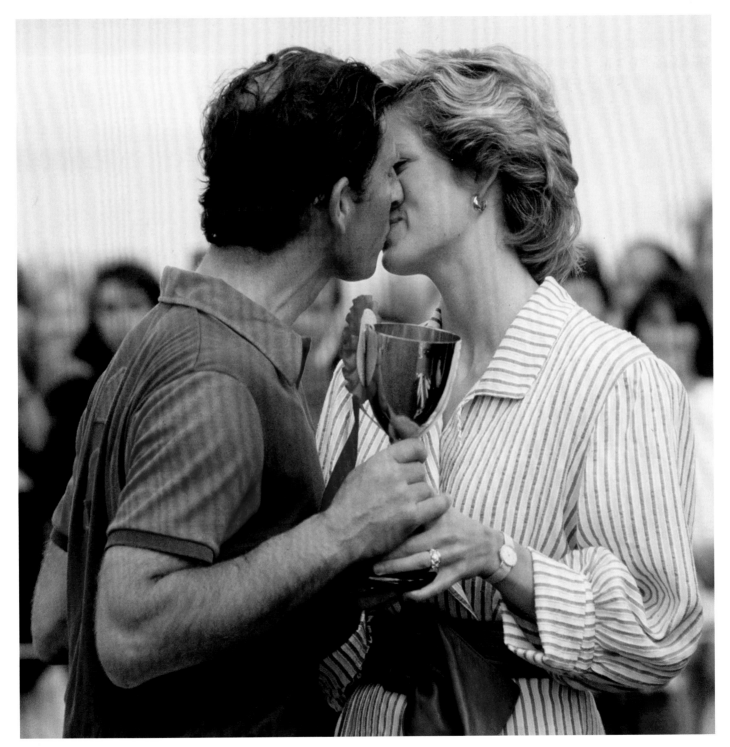

RIGHT: The royal couple have a private audience with Pope John Paul II
at the Vatican in April 1985. Following the Holy See protocol,
Diana wears a veil and a black dress, which was designed by Catherine Walker,
who would create more than 1,000 outfits for her.

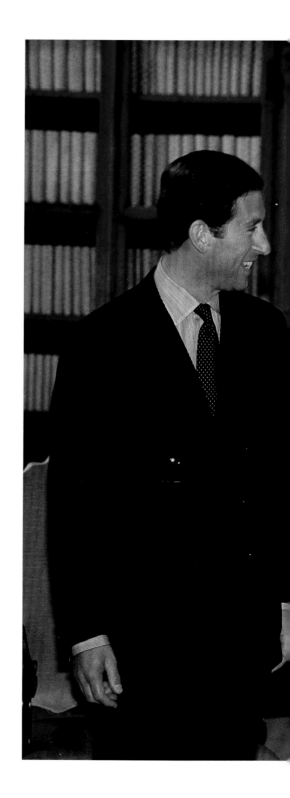

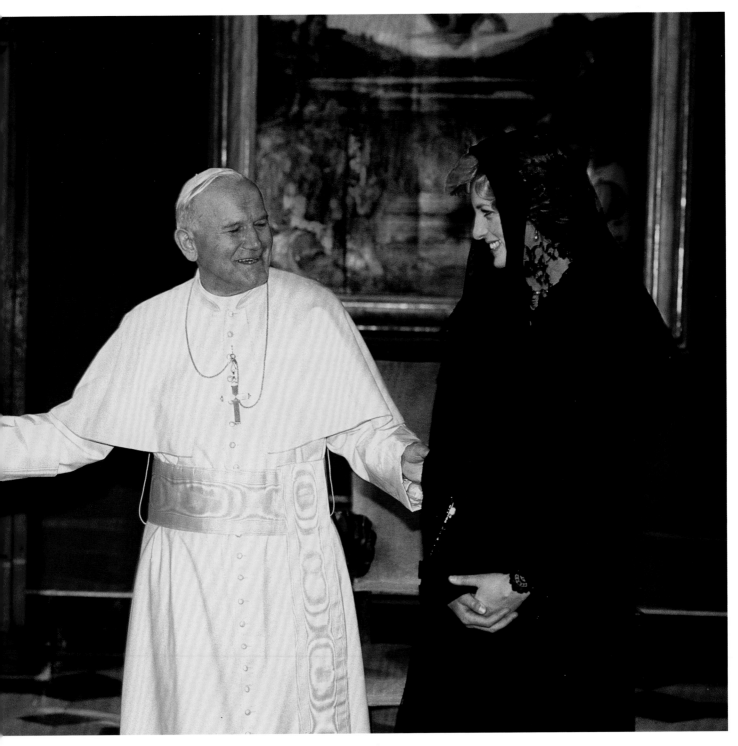

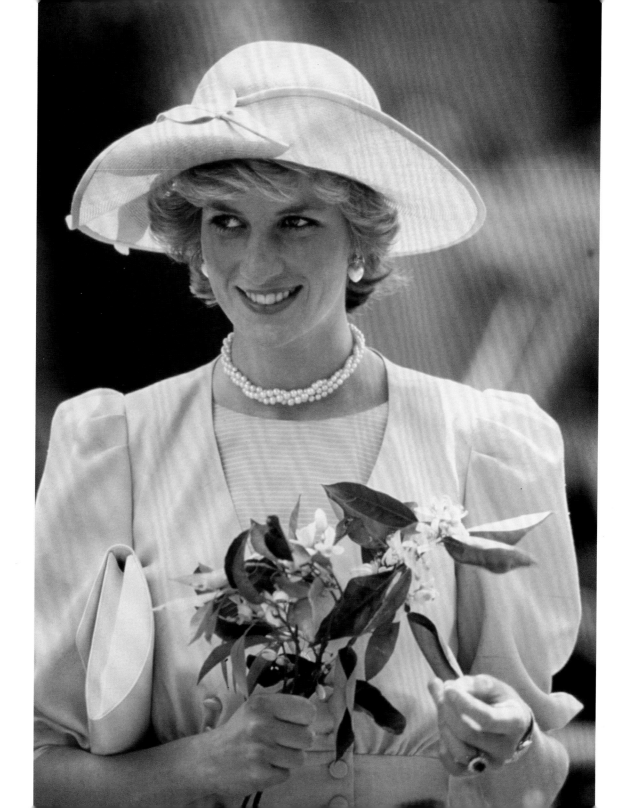

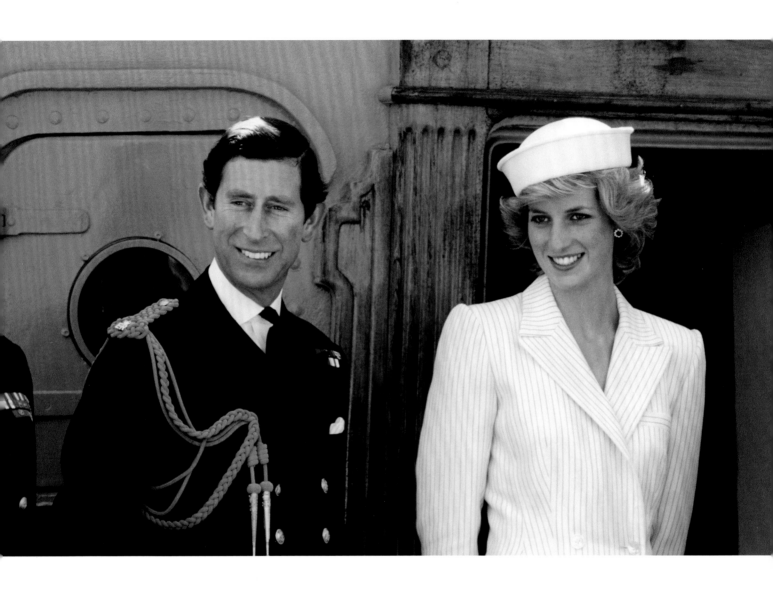

ABOVE: During a tour of Italy, the couple shine as a glamorous and globe-trotting example of royalty aboard a boat in La Spezia. *April 20, 1985*

·OPPOSITE: Pretty in a pink frock designed by Catherine Walker, Diana holds orange blossoms during a visit to Sicily, Italy. *April 30, 1985*

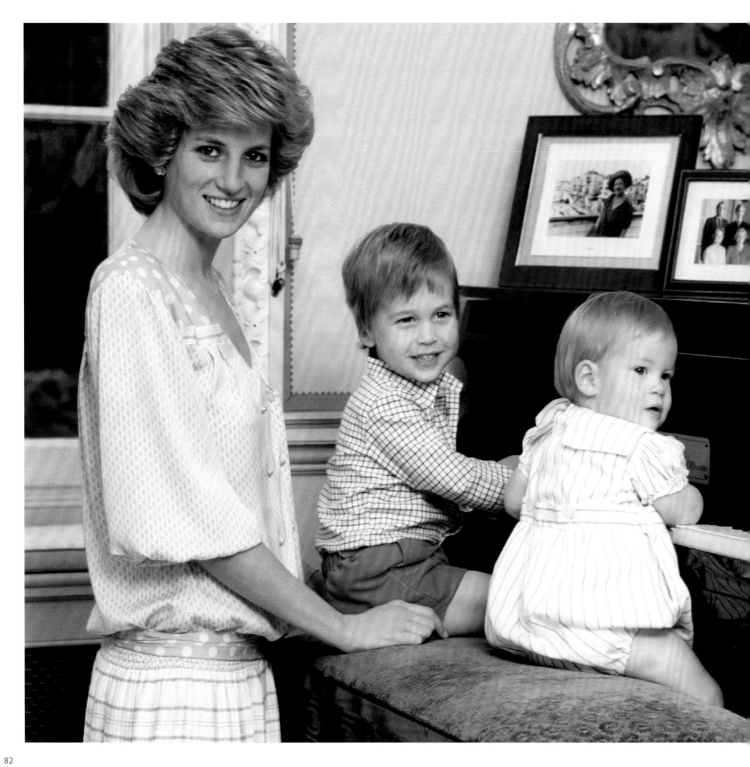

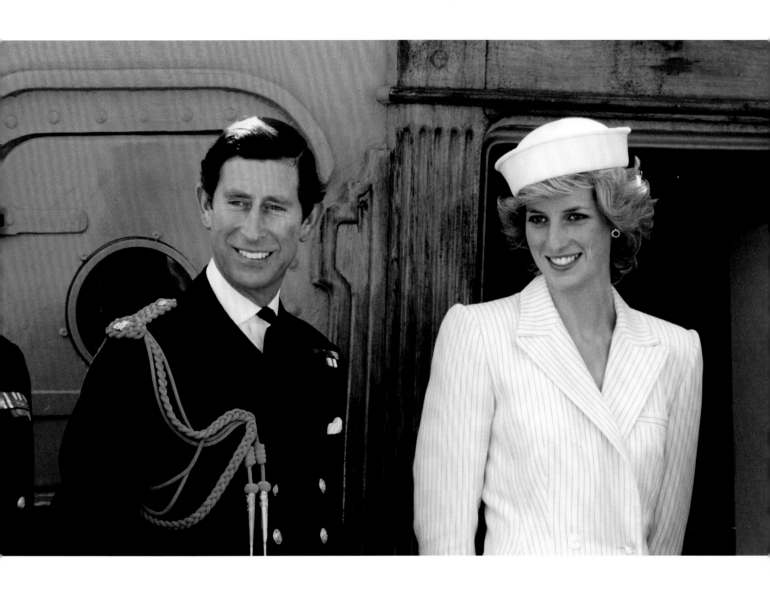

ABOVE: During a tour of Italy, the couple shine as a glamorous and globe-trotting
example of royalty aboard a boat in La Spezia. *April 20, 1985*

·OPPOSITE: Pretty in a pink frock designed by Catherine Walker,
Diana holds orange blossoms during a visit to Sicily, Italy. *April 30, 1985*

## CLASSIC DIANA

Movie star John Travolta and Diana cut a rug at the White House in November 1985 in the company of President Ronald Reagan and his wife, Nancy. Diana and Charles ended their first day in the United States with a gala dinner and dance. In a midnight blue velvet dress designed by Victor Edelstein, accented with a diamond and sapphire choker, Diana captured the room. The iconic image encapsulates Diana's star power. That intense attention and media frenzy became a sticking point for Prince Charles.

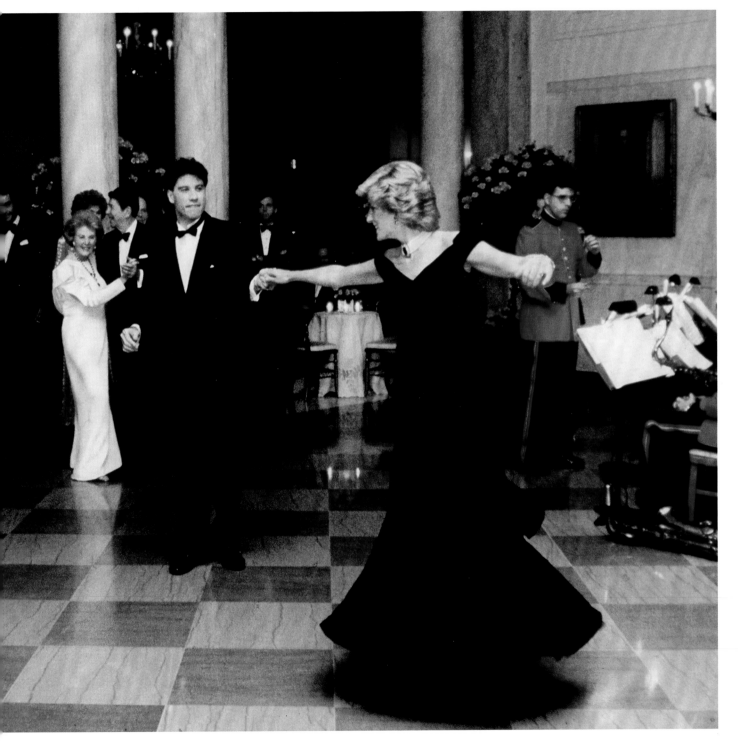

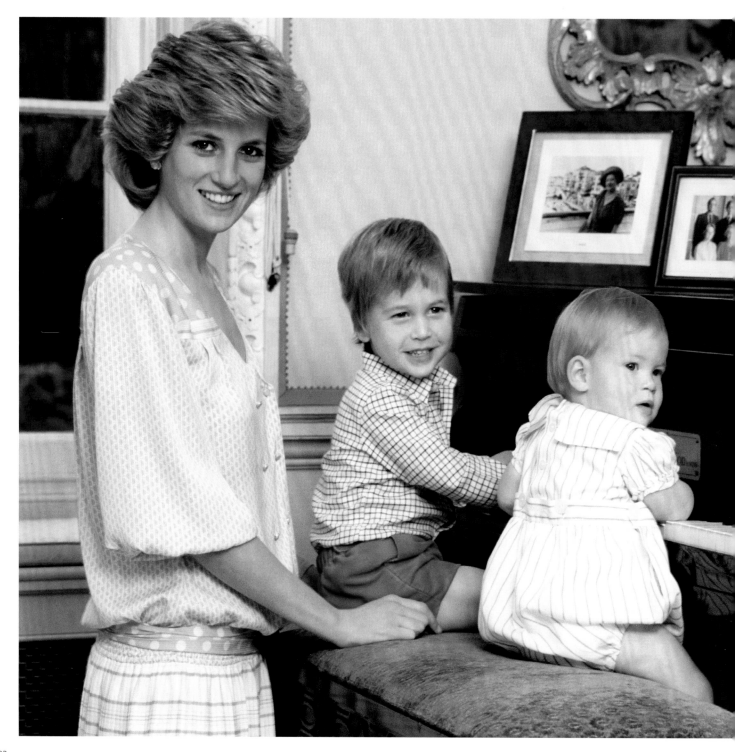

LEFT: Diana kneels with three-year-old Prince William and Prince Harry, who had just turned one the month before, at the piano in Kensington Palace in October 1985. Diana, a fluent piano player, had learned to play as a young girl. She loved classical music, especially Verdi's *Requiem*.

RIGHT: Princess Diana talks with Saudi officials during a state dinner in November 1986. She and Charles also traveled to Oman, Qatar, and Bahrain during the official visit.

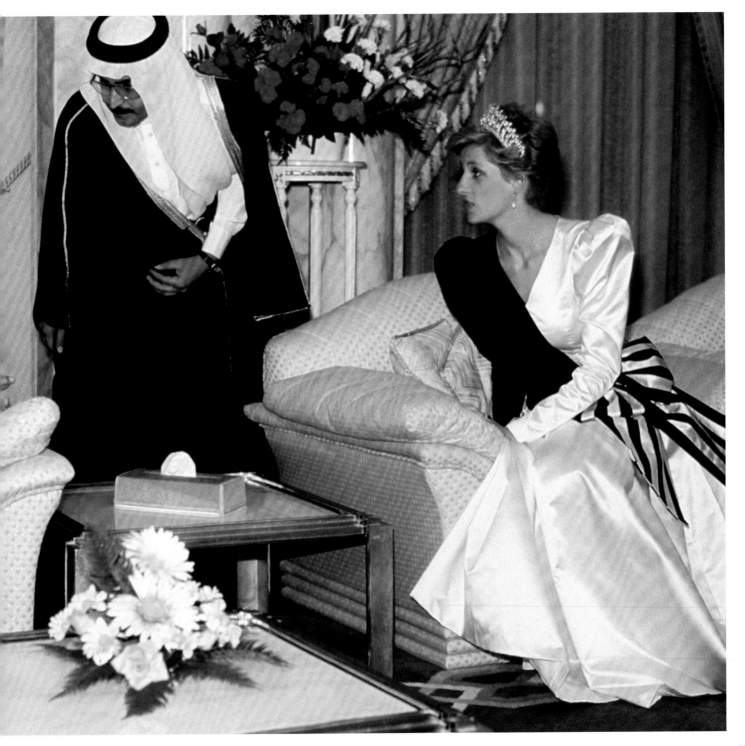

"She will always be remembered
for her amazing public work,
but behind the media glare, to us,
just two loving children, she was quite
simply the best mother in the world."

—PRINCE HARRY,

AT AN AUGUST 2007 MEMORIAL SERVICE

---

OPPOSITE: A summer meadow awash in wildflowers highlights the family as Charles and Diana
hold their sons (Harry, left, and William, right) in front of Highgrove House, in Gloucestershire.
The formal portrait of a happy couple helped to satiate the increasingly ravenous public. *July 1986*

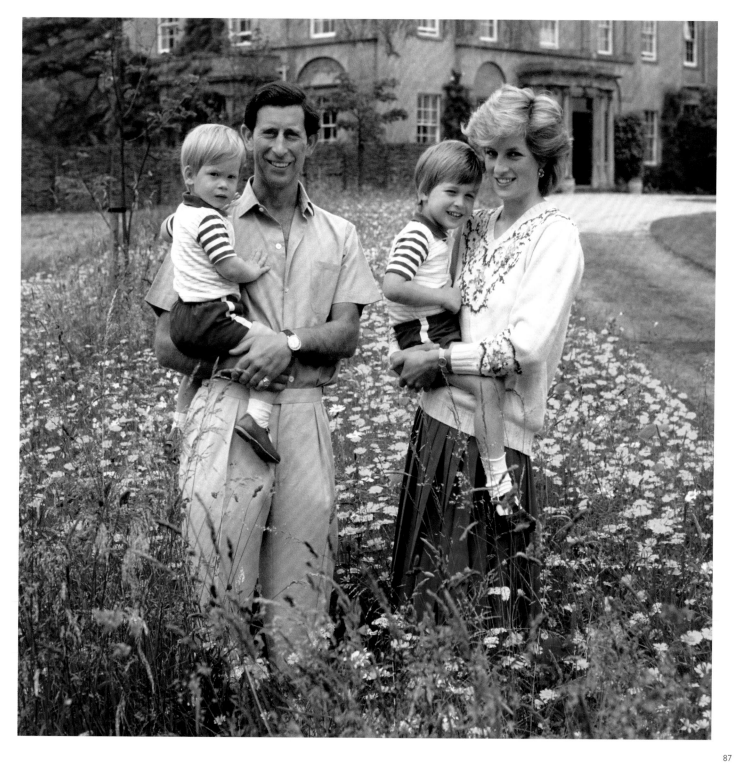

RIGHT: At Highgrove, Diana rests with her head in her hands. Charles had asked Diana to Highgrove when they were dating, and she would later undertake an interior renovation of the manor house led by designer Dudley Poplak. *1986*

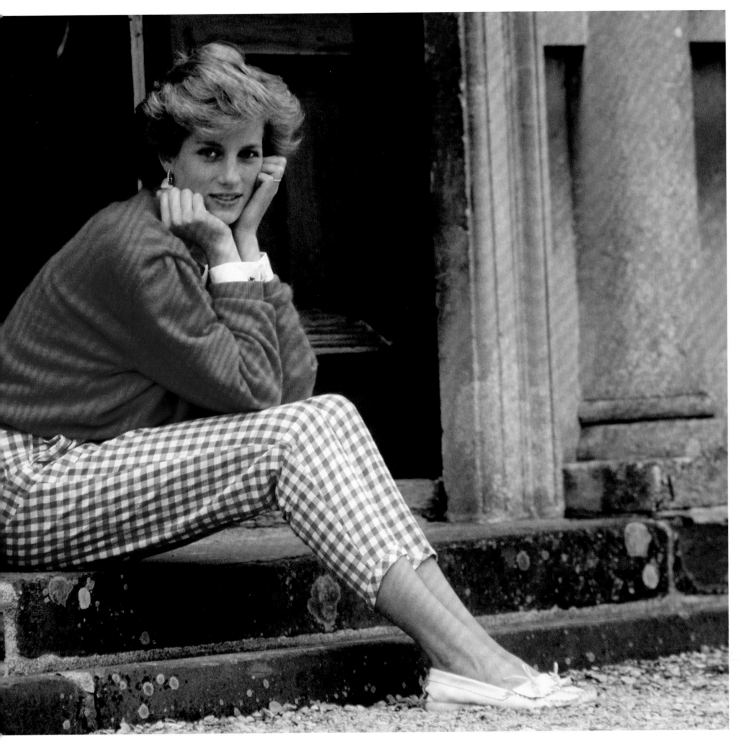

RIGHT: Members of the Vienna Boys' Choir surround Diana during a visit to Austria in April 1986. The state visit was in support of British Week in Vienna. Diana, who effortlessly connected with people from all walks of life, brought a sense of levity to what was typically considered stuffy, royal proceedings.

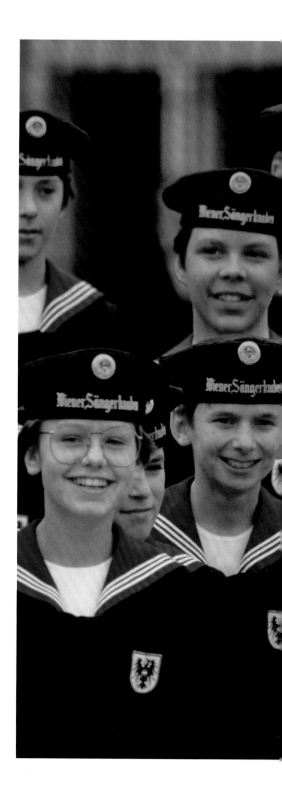

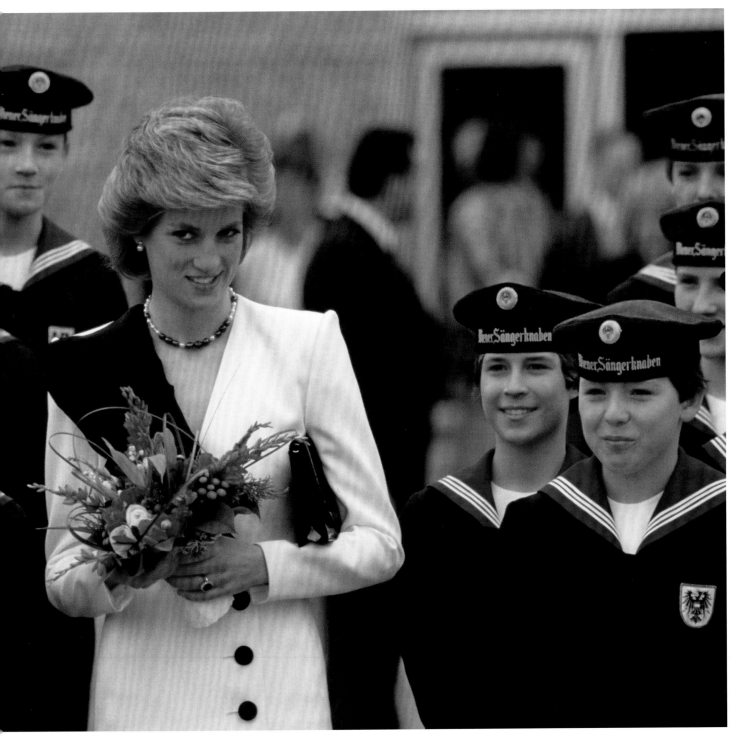

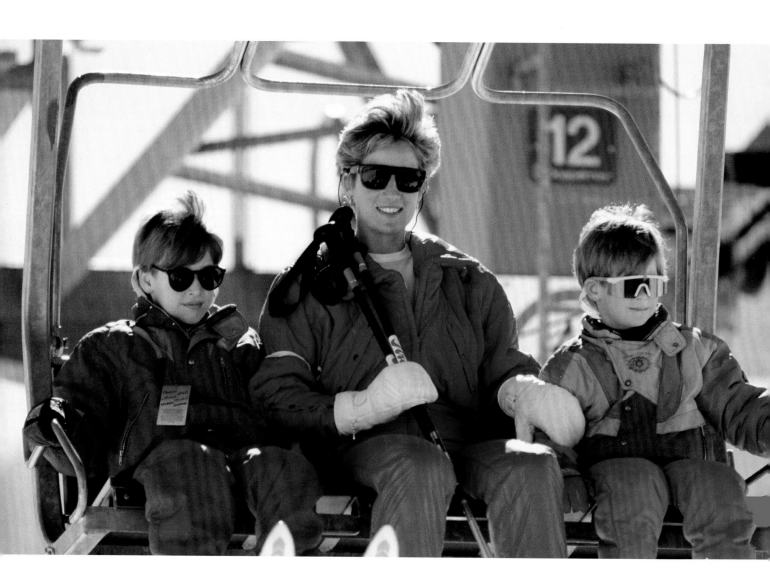

In April 1991, Diana took both boys skiing in Lech, Austria. A lifetime skier, Diana took pleasure in teaching her sons the sport. These vacations, and the requisite photo ops, would become a part of the boys' lives.

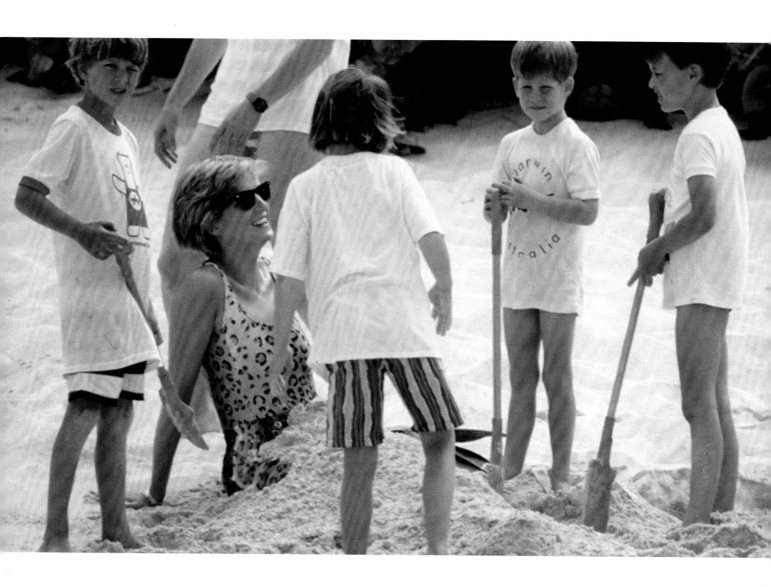

William and Harry, along with their cousins, cover Diana in the sand of Necker Island in April 1990. The beach, a retreat in the British Virgin Islands owned by Richard Branson, was a welcome respite for the princess, this time without Prince Charles.

The most daunting aspect was the media attention, because my husband and I, we were told when we got engaged that the media would go quietly, and it didn't. And then when we were married they said it would go quietly, and it didn't. And then it started to focus very much on me, and I seemed to be on the front of a newspaper every single day, which is an isolating experience, and the higher the media put you, place you, the bigger the drop."

—PRINCESS DIANA,

IN BBC'S 1995 *PANORAMA* INTERVIEW WITH MARTIN BASHIR

OPPOSITE: During a visit to Coventry, England, Diana's camel coat and Cossack hat highlight her style, but it's her easy smile that captured her fans. *October 16, 1985*

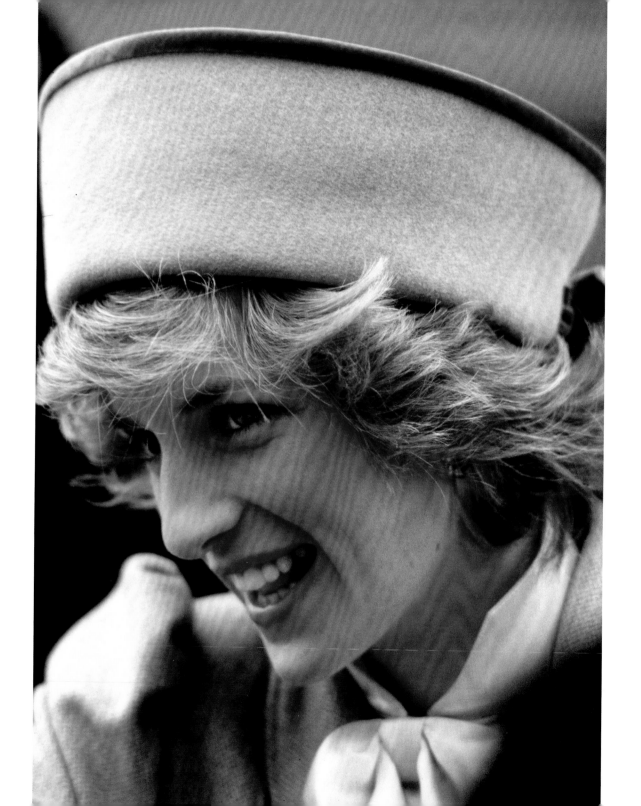

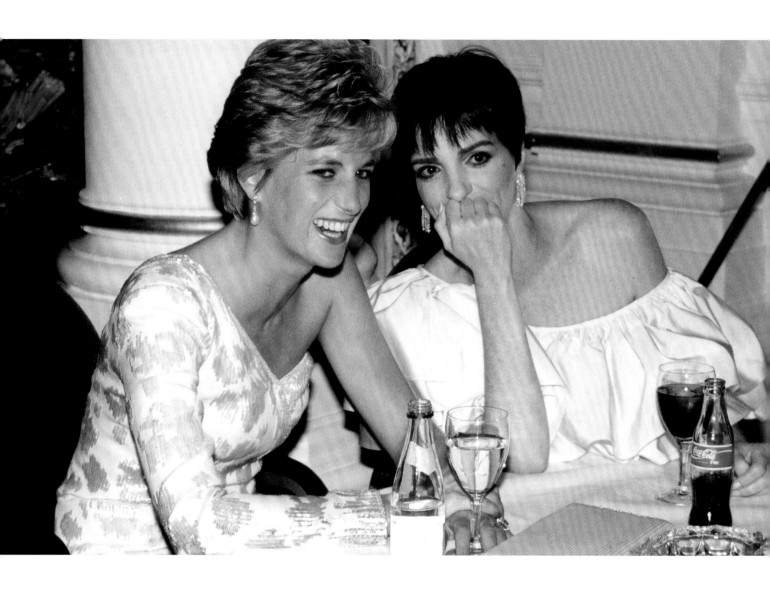

Diana shares a laugh with friend Liza Minnelli at the Langham Hotel in London in 1991. The two attended a party following the charity film premiere of Minnelli's musical comedy *Stepping Out*.

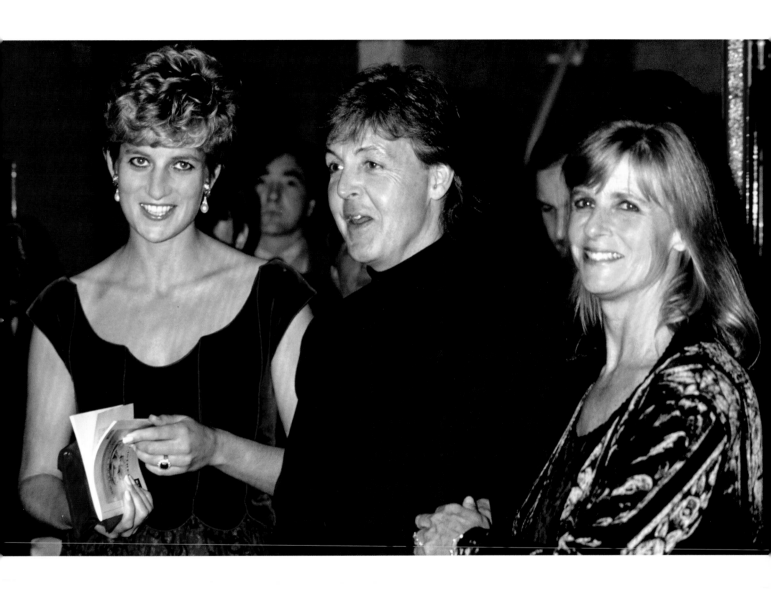

Paul and Linda McCartney join Diana at the Lille Congress Hall in France
on November 15, 1992, for a performance of Paul McCartney's classical
album *Liverpool Oratorio*.

RIGHT: During an official visit to Egypt in May 1992, Diana admires the tomb of Pharaoh Seti l. The tomb's painted reliefs and religious texts make it one of the most fully decorated in the Valley of the Kings. The visit, taken without Charles, who was vacationing with friends in Turkey, took place after a season of tabloid stories about the poor state of her marriage. It proved her professionalism and sense of duty as she won over the press.

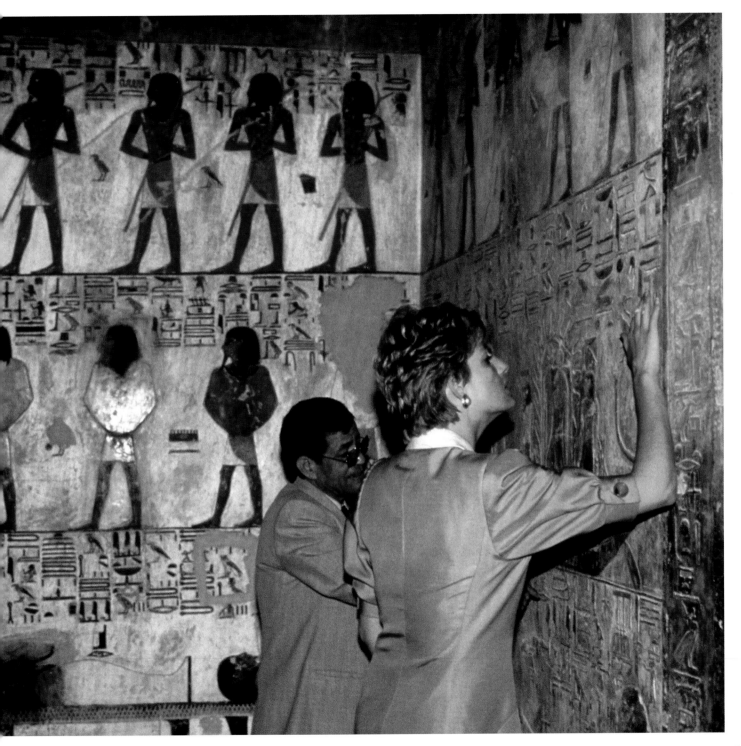

"You can feel and see when she is talking and visiting that she really connects and cares about what she is doing . . . I think that infectious enthusiasm and the energy that she had really rubbed off on me."

—PRINCE WILLIAM,

IN AN INTERVIEW FOR WILDLIFE PRESERVATION IN AFRICA

OPPOSITE: Sharing a personal moment with his mom, Prince William takes a time-out from watching the tennis match at Wimbledon in the summer of 1991.

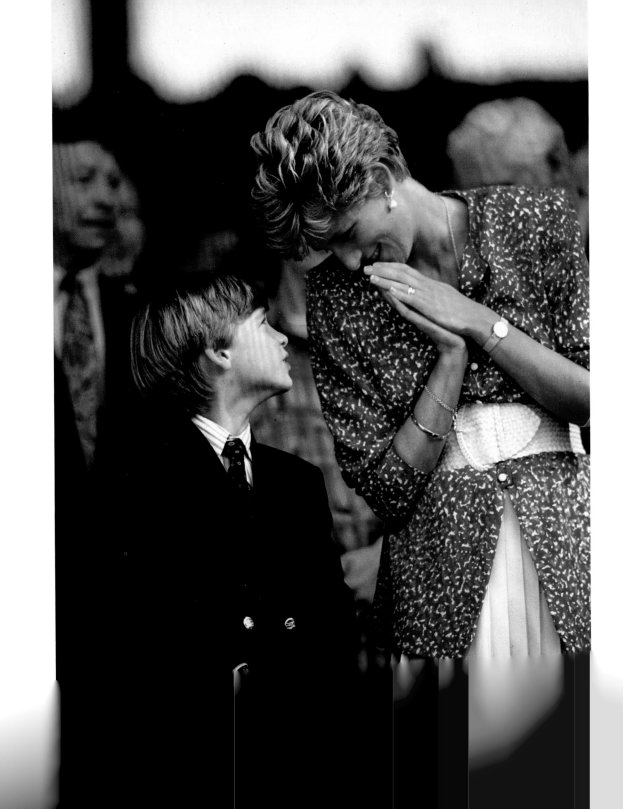

## CLASSIC DIANA

Diana sits in front of the Taj Mahal in the famous "princess alone" photo. Charles was meeting with business leaders in Bangalore at the time—a not-uncommon occurrence on state visits. Diana, however, knew that with the press analyzing their every move, this image would cast wide-ranging ripples. And it definitely did. The press recalled how Charles had sat on the same bench 12 years earlier and said, "One day I would like to bring my wife here." She came, but by that time in their marriage the end was already in sight. *February 1992*

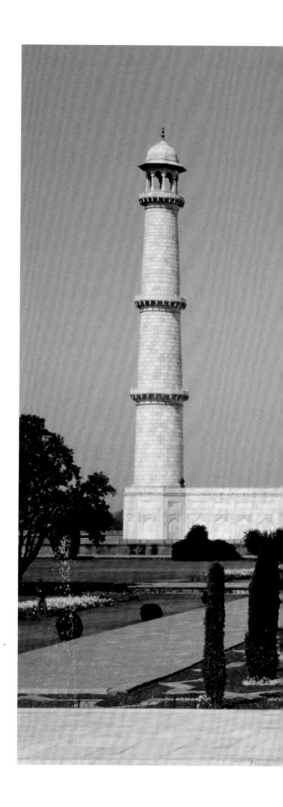

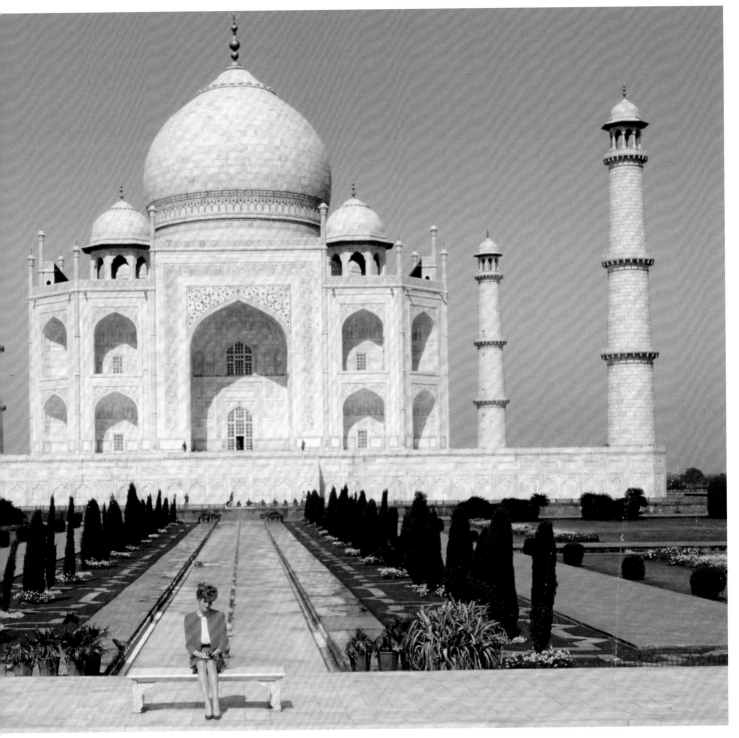

PART THREE *The* PEOPLE

'S PRINCESS

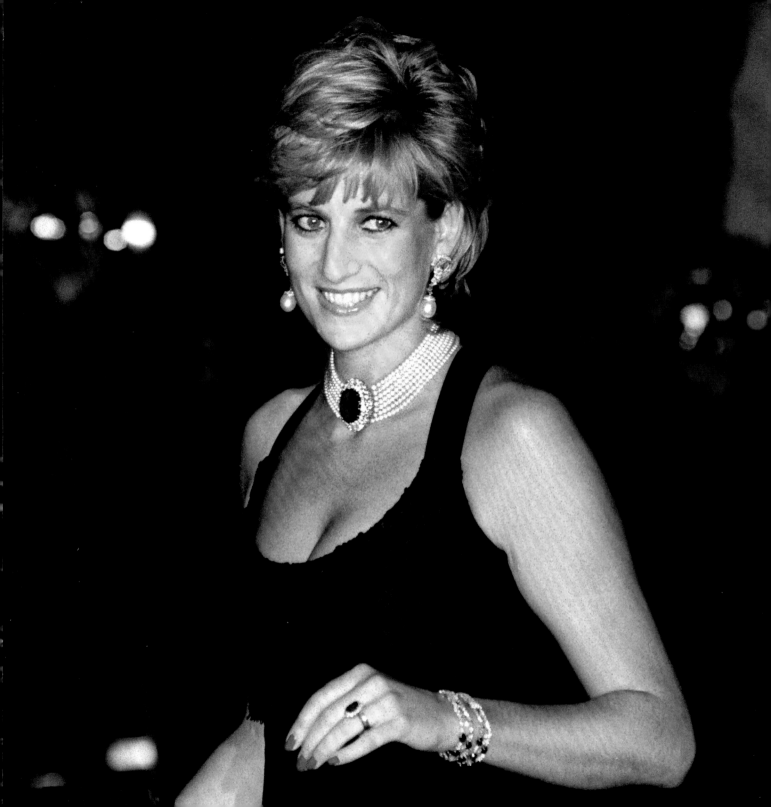

**D**iana was many things to many people: a loving mother, a royal rebel-rouser, a fashion icon, an unhappy wife, a humanitarian. But she always remained steadfastly true to herself. Royal duties called for international meetings with dignitaries, presidents, and ambassadors. And at every new destination, Diana made sure to visit children, the sick, and the poor.

Everyone who met her, whether international rock stars or land mine victims, felt the power of her inner light. In the iconic images that graced the front pages of newspapers and magazines, it's impossible to miss. Diana reaches out, grasps hands with, and looks into the eyes of children. But it was also what happened away from the cameras that endeared her to those she met. When she was dispatched by Buckingham Palace in 1987 to open the U.K.'s first AIDS ward, her ability to connect and intrinsic empathy were on full display. A photograph of her shaking hands with a patient while not wearing gloves appeared in newspapers around the globe and helped remove the stigma surrounding the disease. Diana realized that through the force of an image, she could help change the world.

Her actions also forced the British royal family to confront how out of touch—and out of step—they had become. Diana knew it wasn't enough to be just a figurehead in fancy clothing; it was necessary to let people understand that you cared about them and that you heard them. She was a role model to many—including her young boys, who carry on her spirit and legacy in their own charitable giving.

---

OPPOSITE: Diana attends a gala charity dinner for cancer research at London's Bridgewater House in November 1995, the same day her explosive BBC *Panorama* interview aired, in which she discussed her infidelity and bulimia.

PREVIOUS PAGES: Post-separation from Charles, Diana posed for photographer Mario Testino. *1997*

RIGHT: Princes William and Harry enjoy an Austrian sleigh ride with their mother in March 1993. Their nanny, Olga Powell, and bodyguard Trevor Bettles ride in the back of the carriage.

FOLLOWING PAGES: In a remote Nepalese community, Diana greets local villagers during a visit to Red Cross projects in the mountainous Asian country. Her support for the Red Cross never wavered. *March 3, 1993*

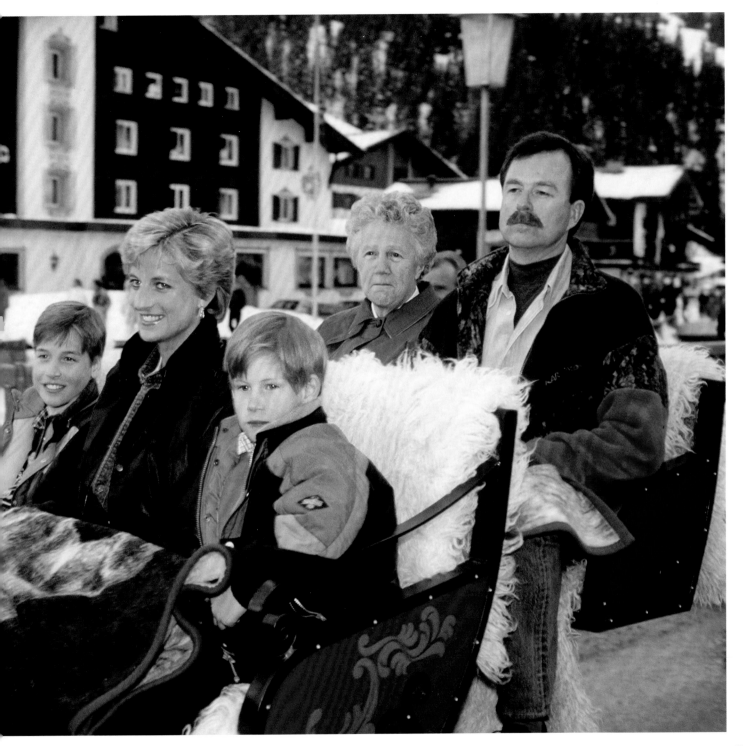

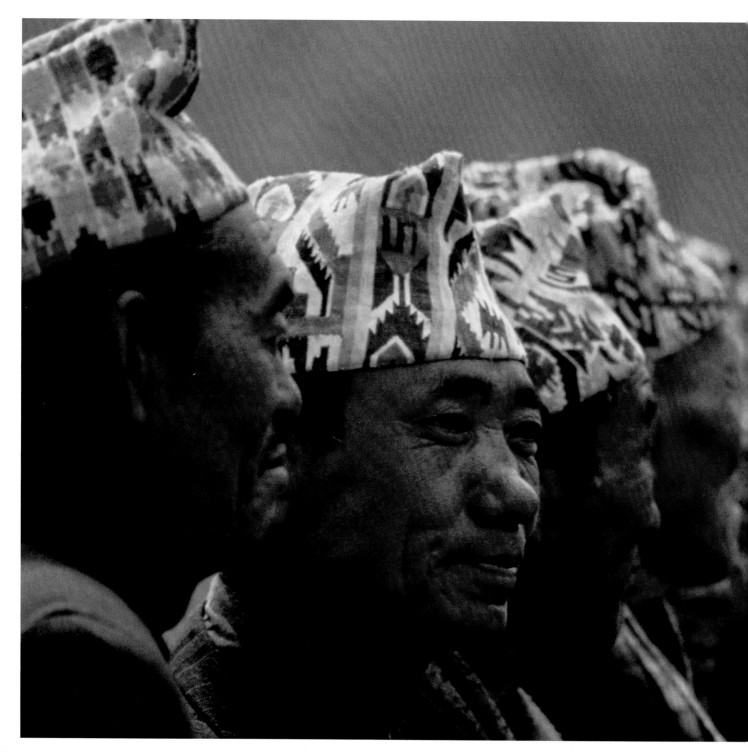

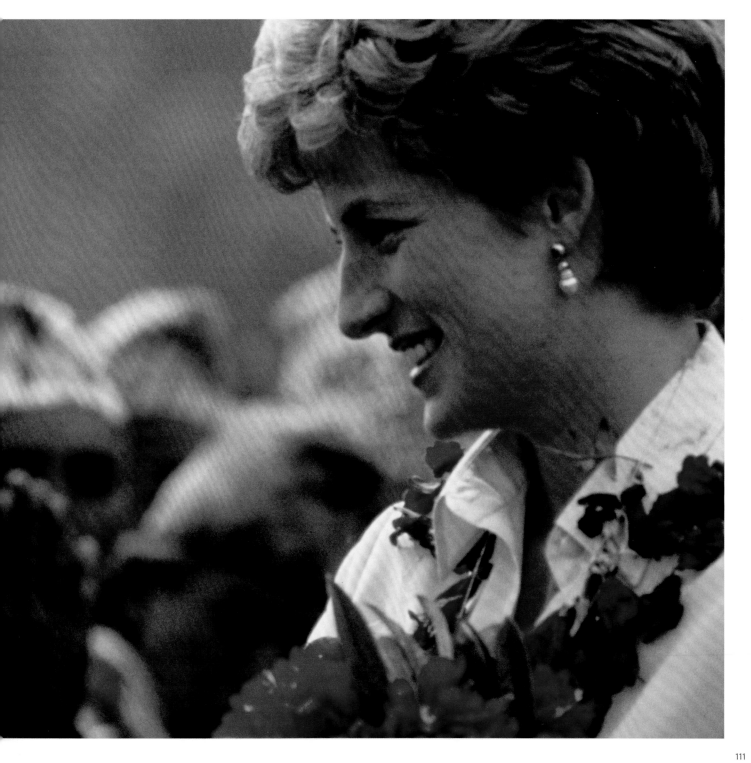

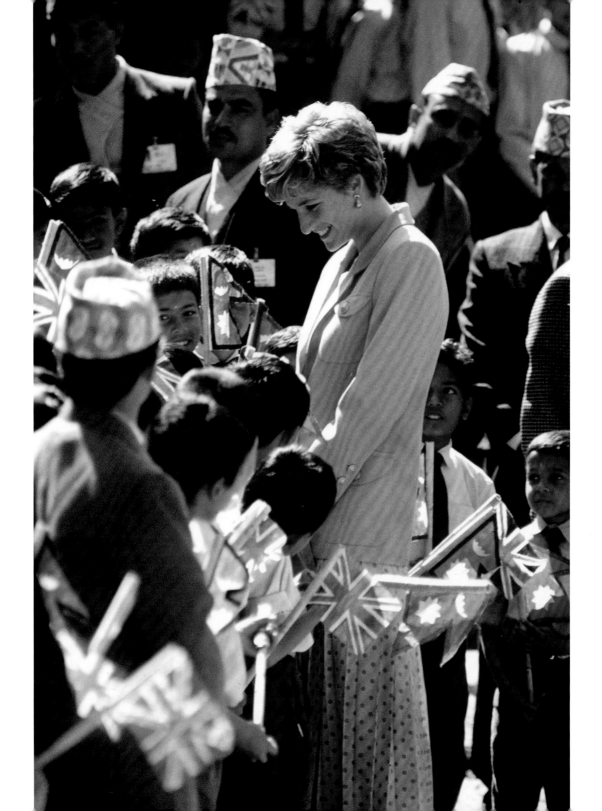

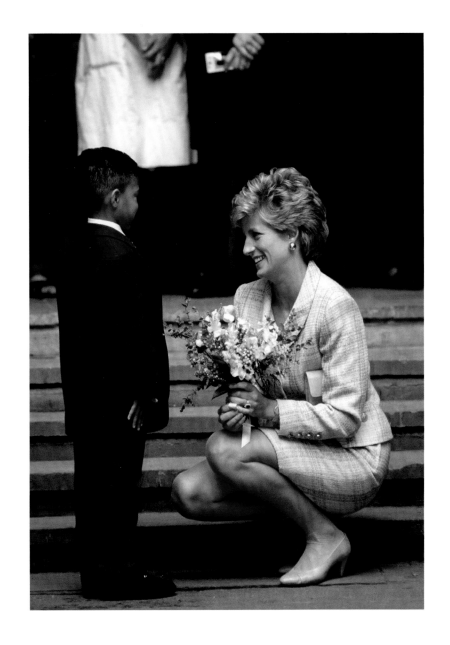

ABOVE: Diana's innate ability to connect with children was one of the most endearing aspects of her life. Here, she crouches down to greet a boy at eye level in front of the Great Ormond Street Hospital in London. *May 10, 1993*

OPPOSITE: Diana greets students at the Budhanilkantha School near Kathmandu, Nepal, in March 1993, during a visit to view Red Cross projects. During her trip, Charles was miles away in Mexico.

RIGHT: Diana found passion in the charitable organizations she worked with. Here, she puts herself to good use at a Red Cross feeding center in Zimbabwe serving refugees, some of whom had walked miles on foot for the meal. Catherine Walker designed her safari suit, but by this time even the jaded press corps focused more on Diana's causes and the sincerity of her compassion than her fashion sense. *July 1993*

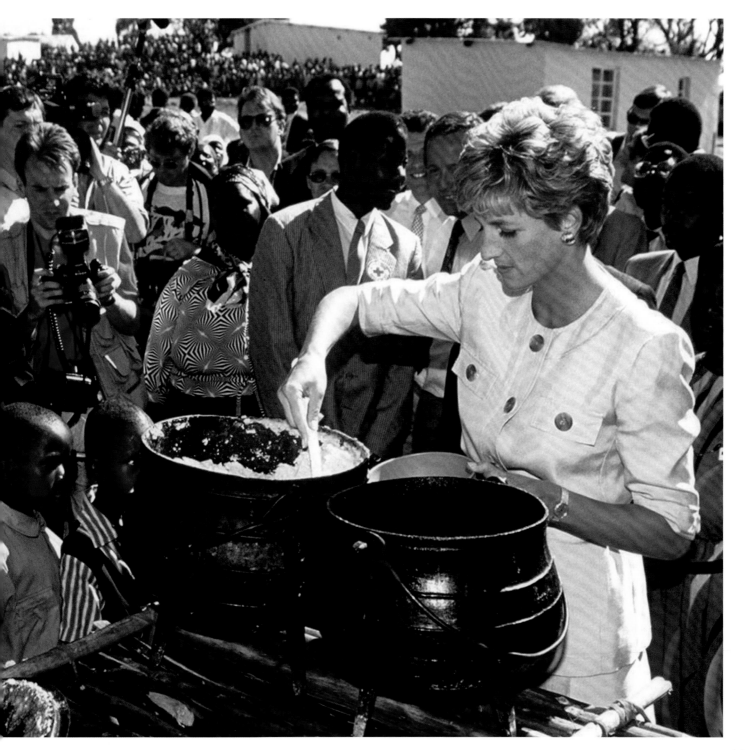

RIGHT: Even post-separation, Diana's official duties took up much of her time. Handling the media attention had become a well-honed skill after more than a decade in the royal family. Diana understood how to use the media to advance her causes as well as her agenda, such as the feeling that she was in a loveless marriage. Here she signs an official portrait. *1993*

FOLLOWING PAGES: Diana and the young princes ride the Logger's Leap at Thorpe Park in Surrey. Their infectious smiles made the family of three easily relatable to the public. Such a normal experience helped erase the lines between royalty and commoner. *April 13, 1993*

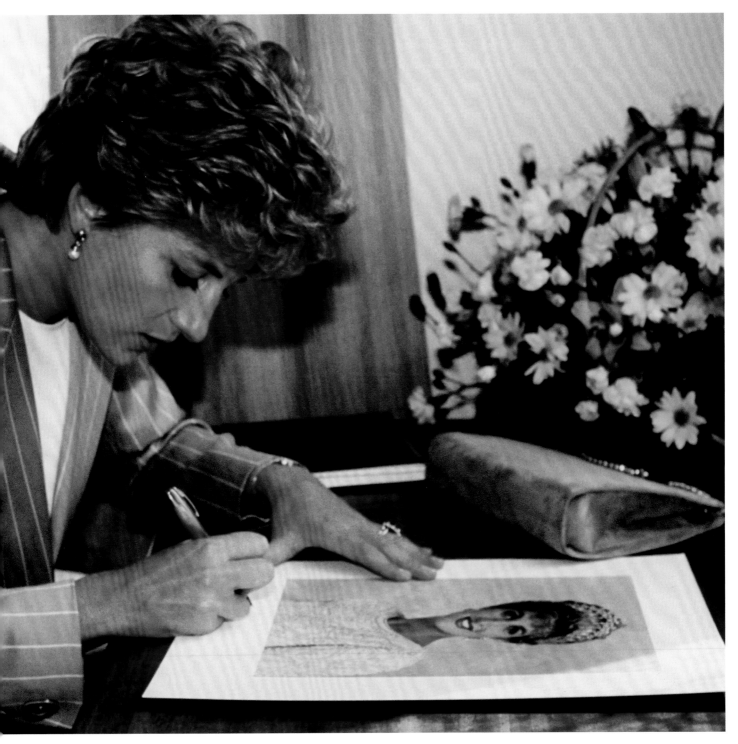

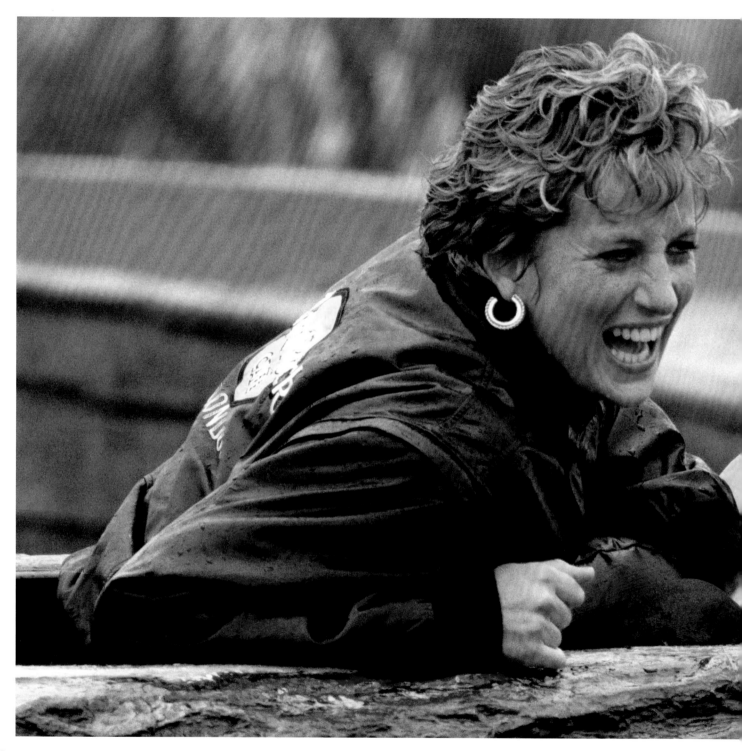

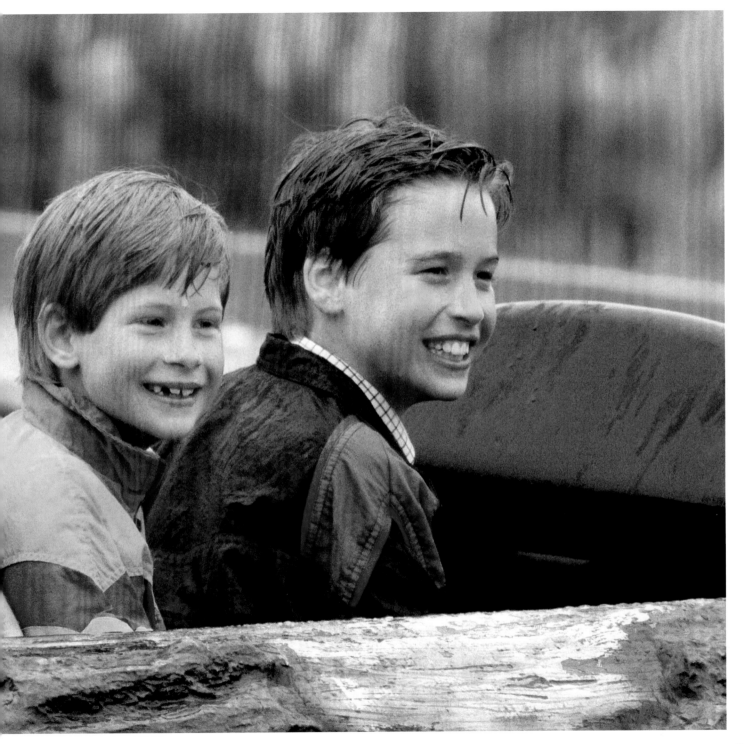

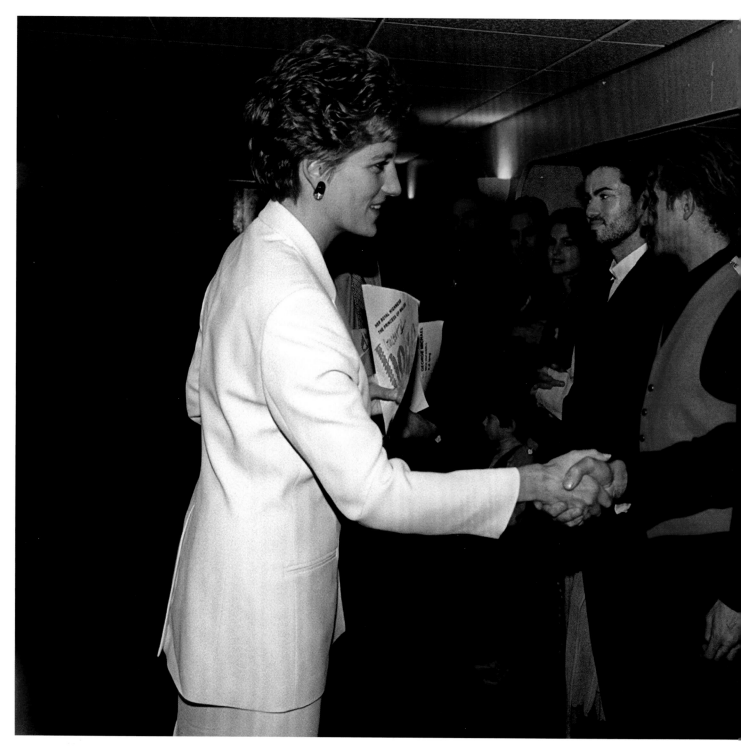

"The royal family didn't like her, the aristocracy didn't like her, but the people liked her. She was vulnerable, she was not a perfect person, and I guess she could be difficult. But she was good. And she cared."

—DOMINICK DUNNE,

JOURNALIST, IN A 2007 CNN INTERVIEW

LEFT: Being a princess has its perks. Diana greets David Bowie backstage at Wembley Arena after a concert to raise money on World AIDS Day in 1993, in London. Bowie, who was the host of the event, asked the crowd to give "a big, big hand" to the princess, the event's patron.

## CLASSIC DIANA

The media surrounding Diana could be relentless. After her separation from Charles in 1992, journalists and editors would regularly visit with Diana, who realized the importance of remaining in the hearts of the public as well as shaping the narrative about her marriage. One adviser cautioned her not to have anything to do with the media, a warning that supposedly shocked her. Here, Diana, who was in France for the second International Night of Childhood, waves to the paparazzi from a car. *November 28, 1994*

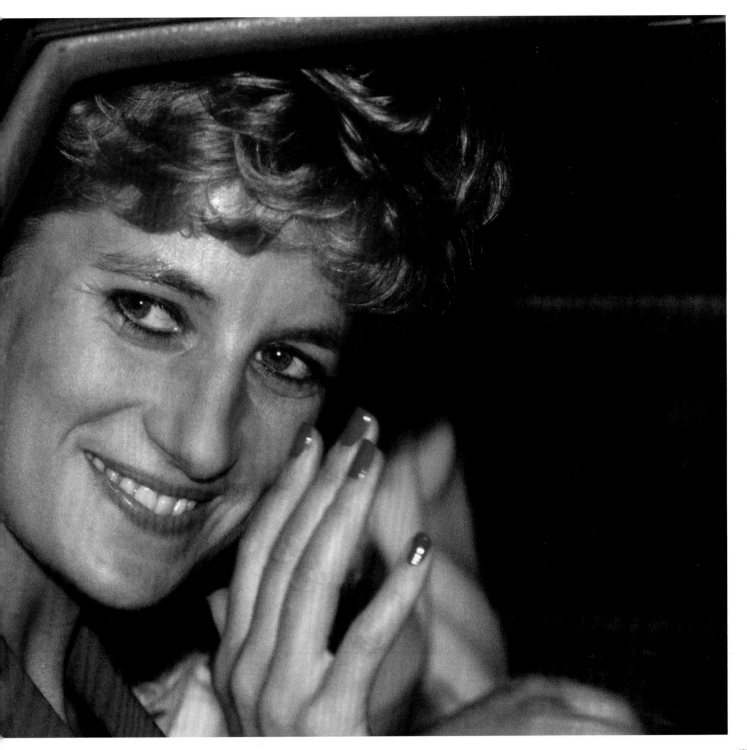

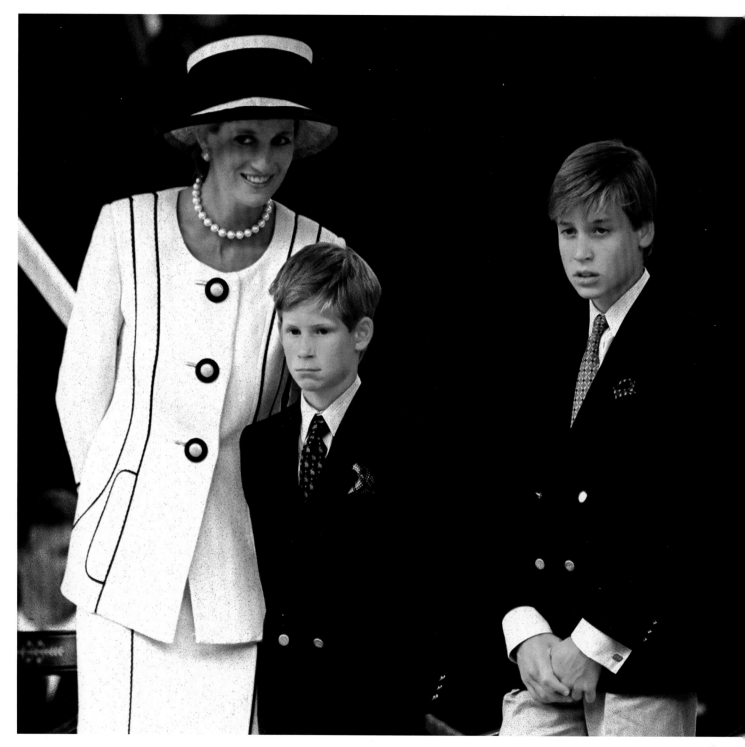

LEFT: Separated but not yet divorced, Diana and Charles come together with their sons for V-J Day, commemorating the day when Japan surrendered in World War II. *August 19, 1995*

RIGHT: After the Hong Kong Open on April 23, 1995, Diana stands with American tennis player Michael Chang (at left), the winner, and Sweden's Jonas Björkman during the awards ceremony. Diana was in town on a private visit.

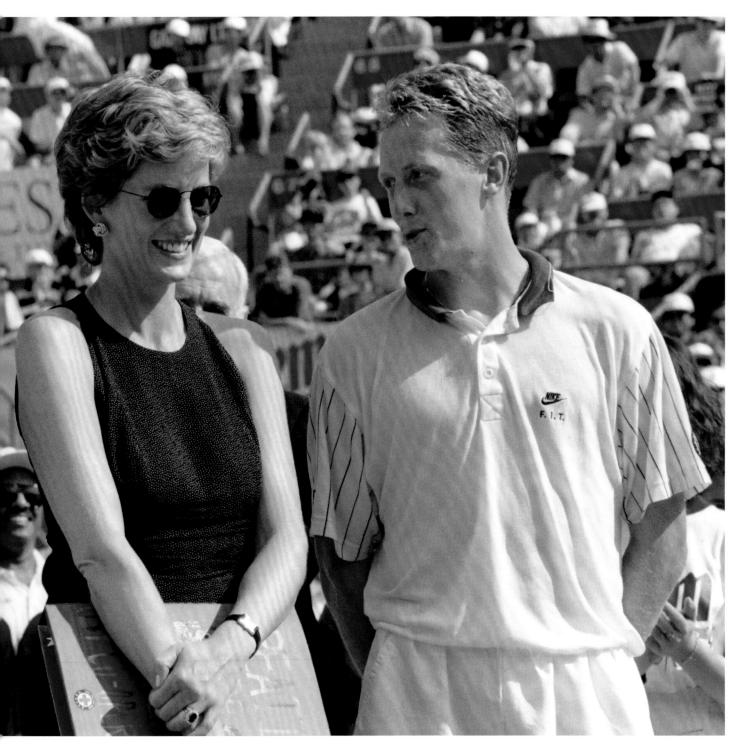

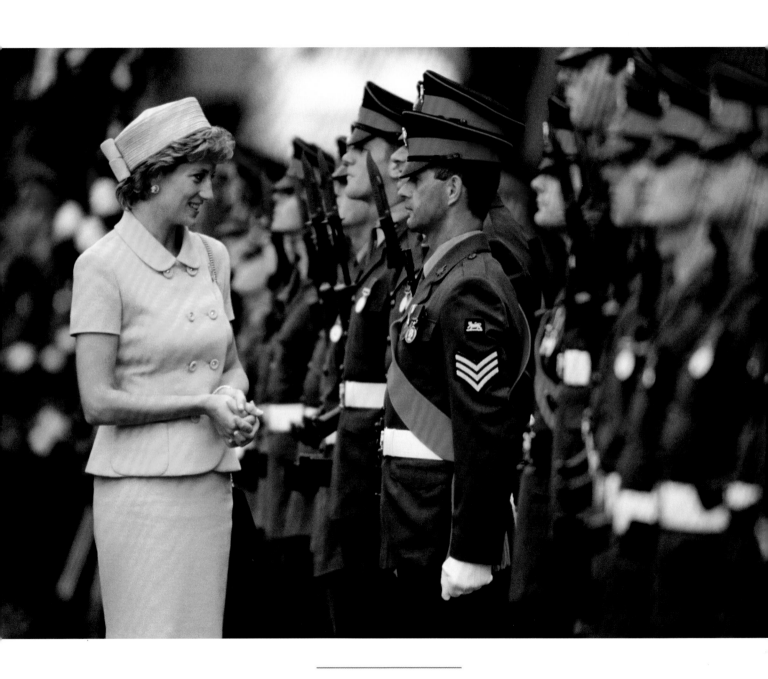

Diana inspects the troops of the Princess of Wales's Royal Regiment. Made up of infantry soldiers from southeast England, the regiment is known as the Tigers, or more colloquially by some as Di's Guys. *May 20, 1995*

"Every one of us needs to show how much we care for each other, and, in the process, care for ourselves."

—PRINCESS DIANA

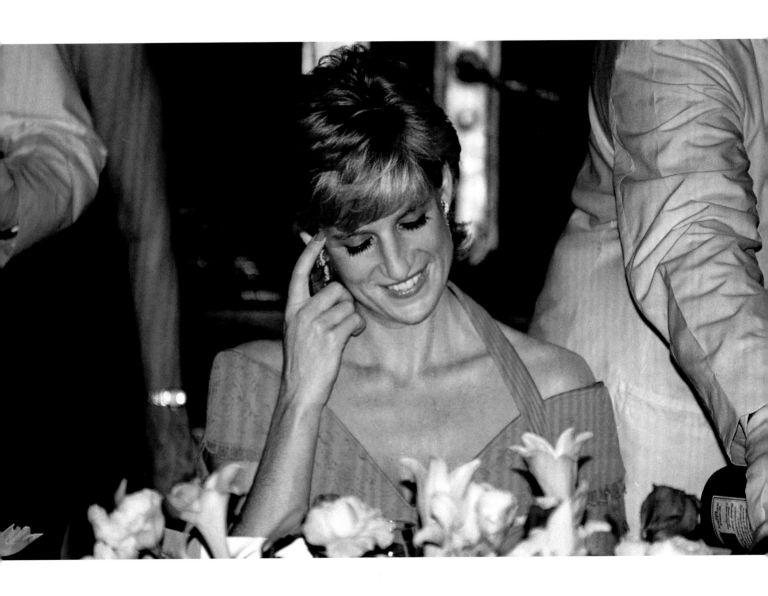

Diana's radiance shines while attending a dinner in her honor in Buenos Aires, Argentina.
Her red dress was designed by Catherine Walker. *November 24, 1995*

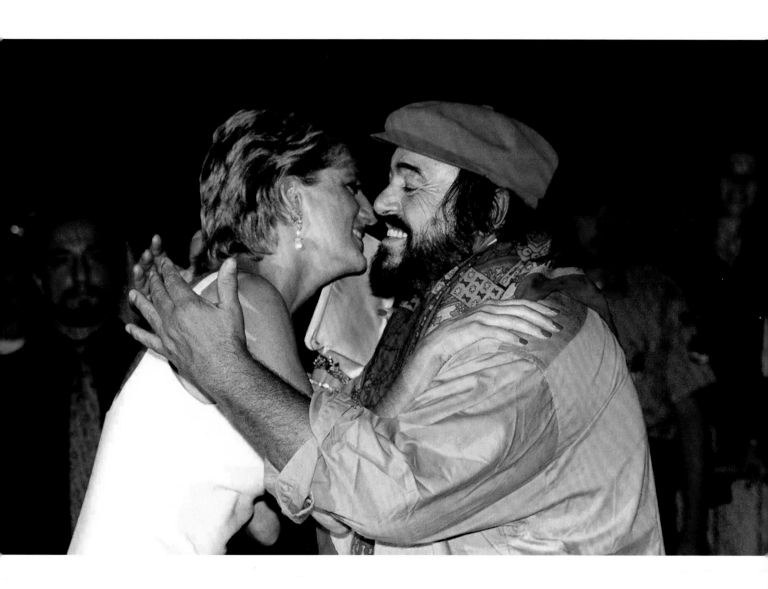

The Italian tenor Luciano Pavarotti greets Diana with a warm embrace as she
arrives for a concert benefiting Bosnian children in Modena, Italy. Diana loved opera;
her favorite composers were Gioachino Rossini and Giuseppe Verdi. *September 12, 1995*

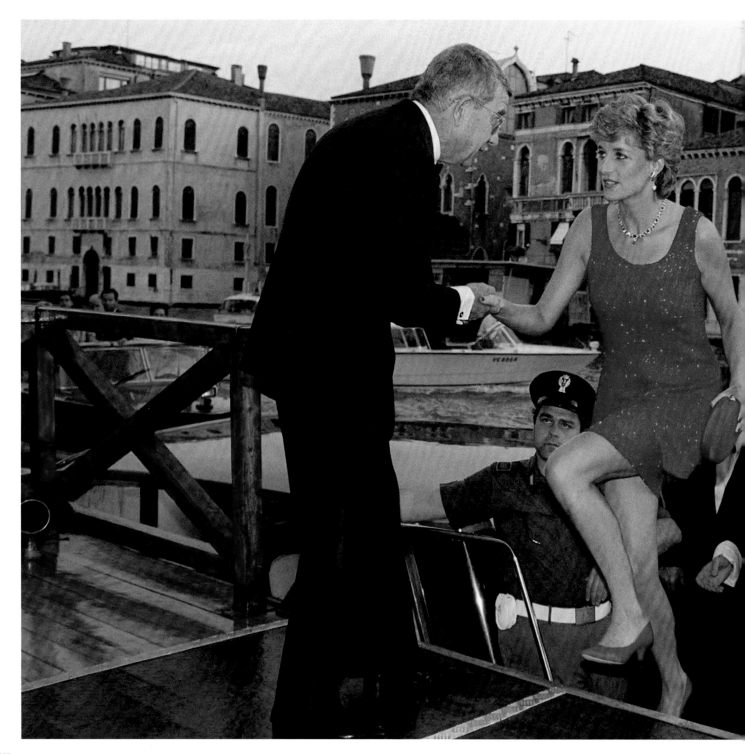

LEFT: Stepping off a boat on Venice's Grand Canal, Diana arrives for a dinner at the Palazzo Grassi dressed in a sparkling red dress designed by Jacques Azagury. *June 8, 1995*

Diana had no idea how much she was loved. To the poor, the sick, the weak, and the vulnerable, she was a touchstone of hope. But her appeal extended much further than that. She had the ability to engage the affections of the young and the old from all walks of life.

"... Her appeal was as simple as it was unique. Diana touched the child in each and every one of us. She wasn't the 'people's princess'—she was the people's friend."

—INGRID SEWARD,

EDITOR IN CHIEF OF *MAJESTY* MAGAZINE,
AS REMEMBERED IN *THE PEOPLE'S PRINCESS*

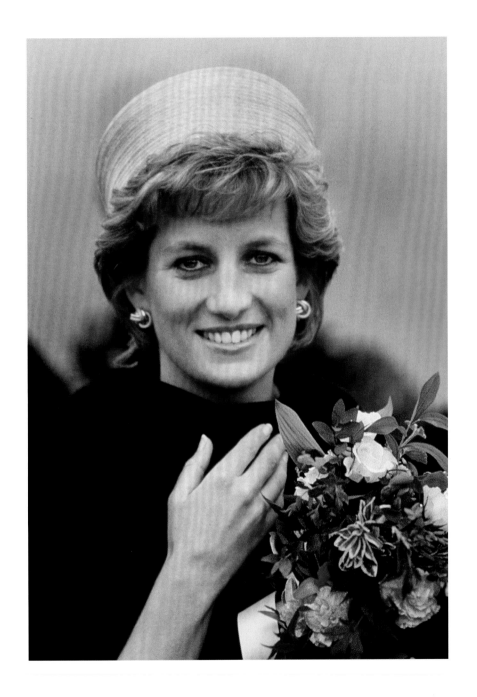

Diana, her hair under a pink pillbox hat, holds a bouquet of flowers during a visit to her regiment on May 20, 1995. She was appointed the regiment's first colonel-in-chief in 1992, but gave up the title in 1996 after her divorce.

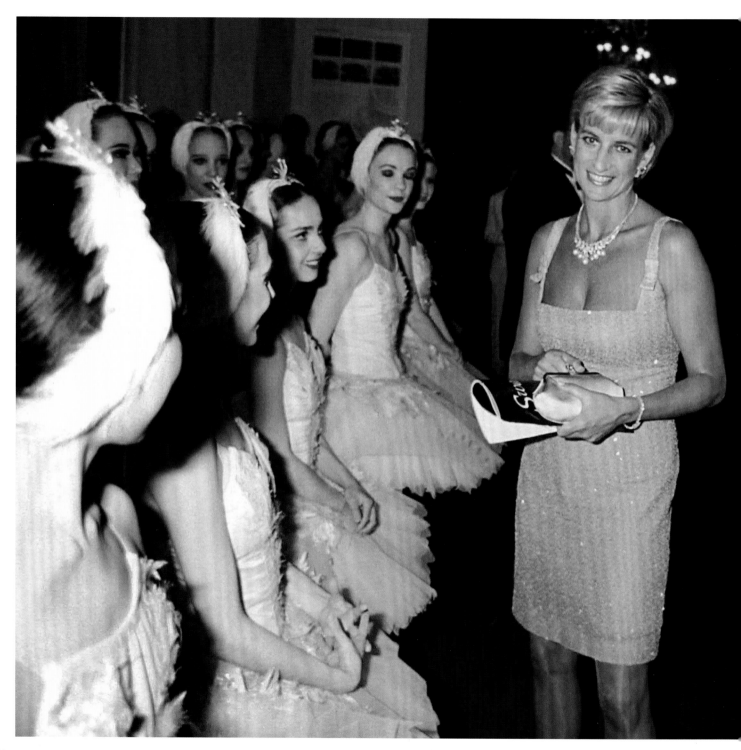

LEFT: Dancers with the English National Ballet greet Diana after their performance of *Swan Lake* at the Royal Albert Hall in London on June 3, 1997. Diana had taken ballet as a child and remained a fan of the art.

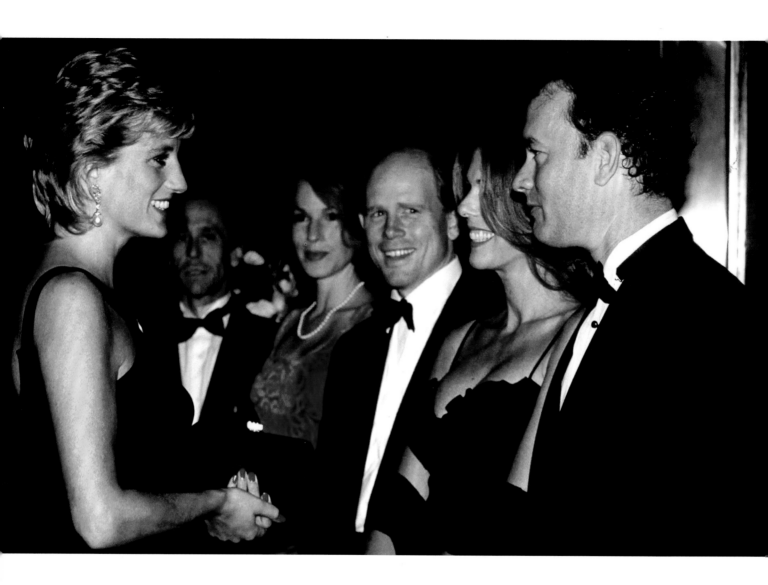

ABOVE: Attending movie premieres was a more glamorous aspect of the princess's life.
Here she meets actor Tom Hanks (at right), his wife, Rita Wilson, and director Ron Howard at
the London premiere of the movie *Apollo 13* in September 1995.

OPPOSITE: The stars come out for Diana during a gala charity dinner in Washington, D.C.
Designer Ralph Lauren and *Vogue* editor Anna Wintour flank the princess on September 24, 1996.

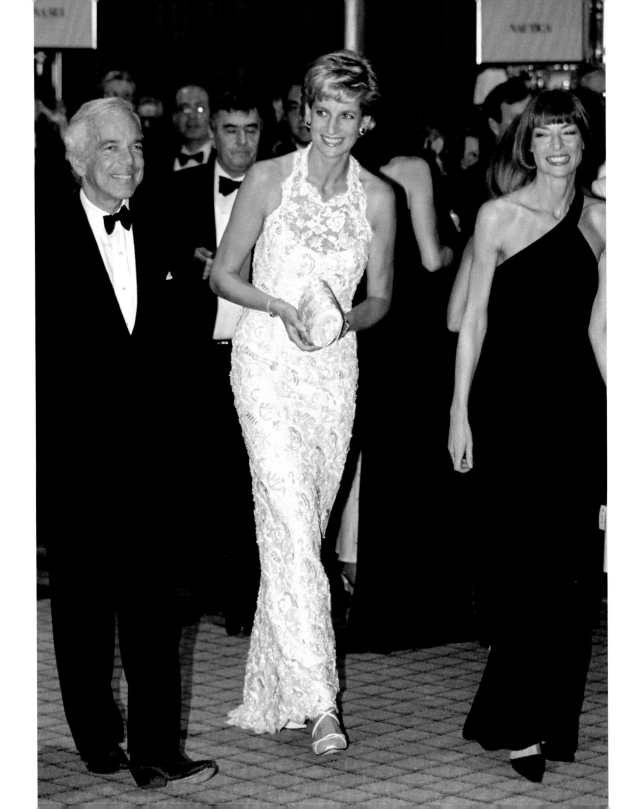

"Nothing brings me more happiness than trying to help the most vulnerable people in society. It is a goal and an essential part of my life—a kind of destiny. Whoever is in distress can call on me. I will come running wherever they are."

—PRINCESS DIANA

OPPOSITE: In July 1995, Princess Diana presents new colors to the Light Dragoon Guards at their base in Bergen-Hohne in northern Germany. Forever fashionable, she wears a Catherine Walker suit and a hat by Philip Somerville.

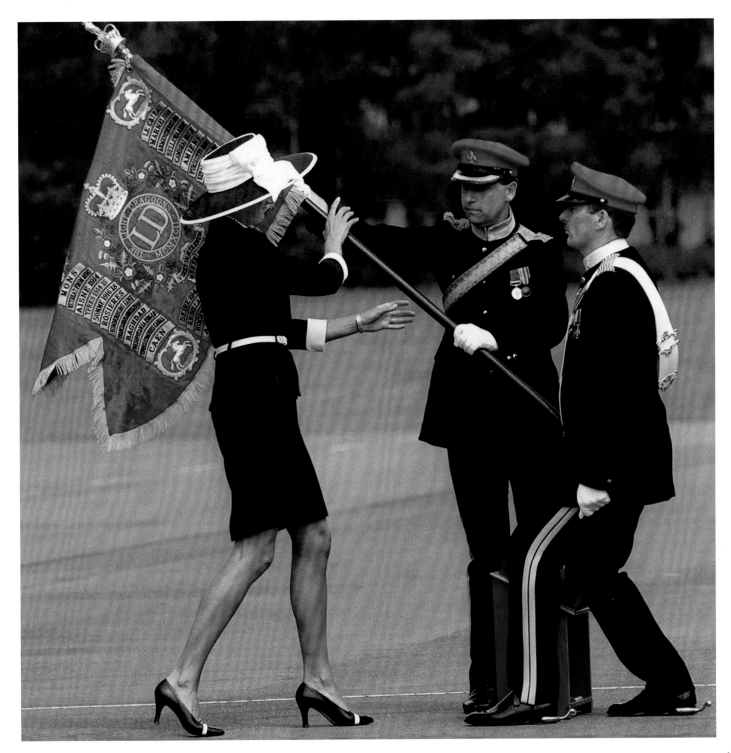

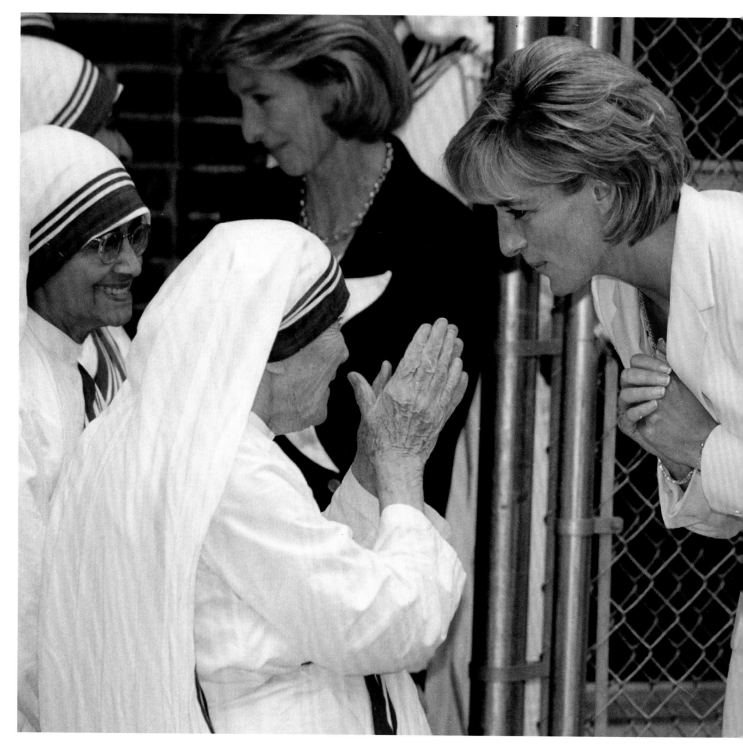

LEFT: Diana meets Mother Teresa, another global icon, at the home of Mother Teresa's Missionaries of Charity's residence in the Bronx, New York. *June 18, 1997*

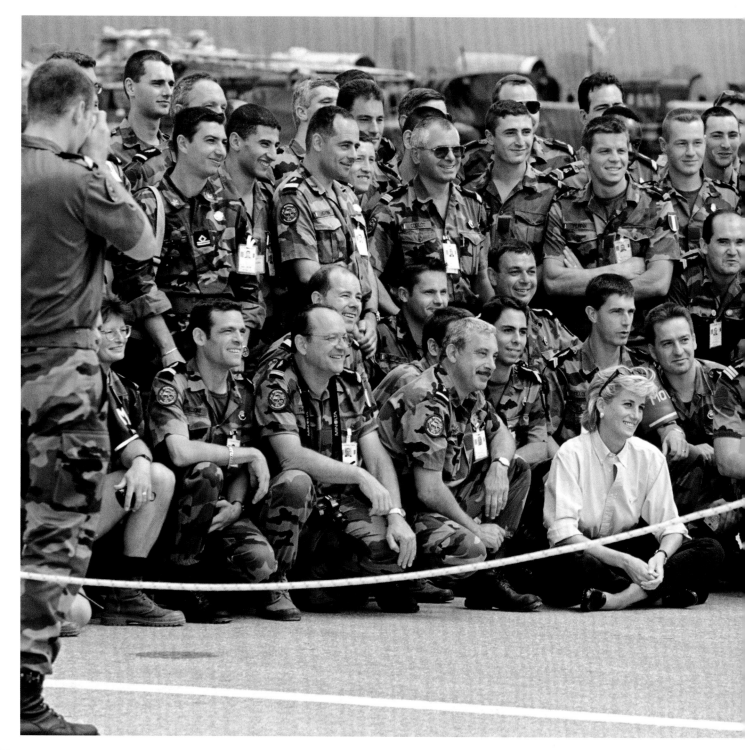

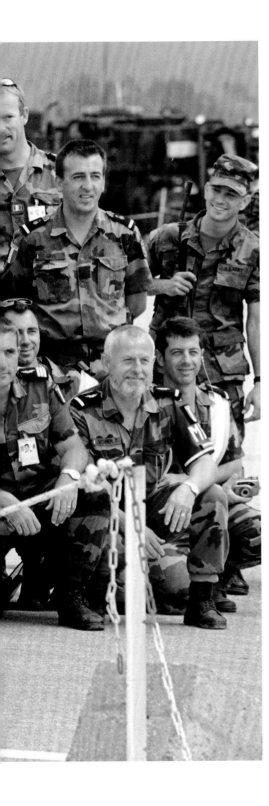

LEFT: Diana sits with French NATO soldiers at Sarajevo airport before her flight back to London. The soldiers were part of a multinational stabilization force for Bosnia and Herzegovina. *August 10, 1997*

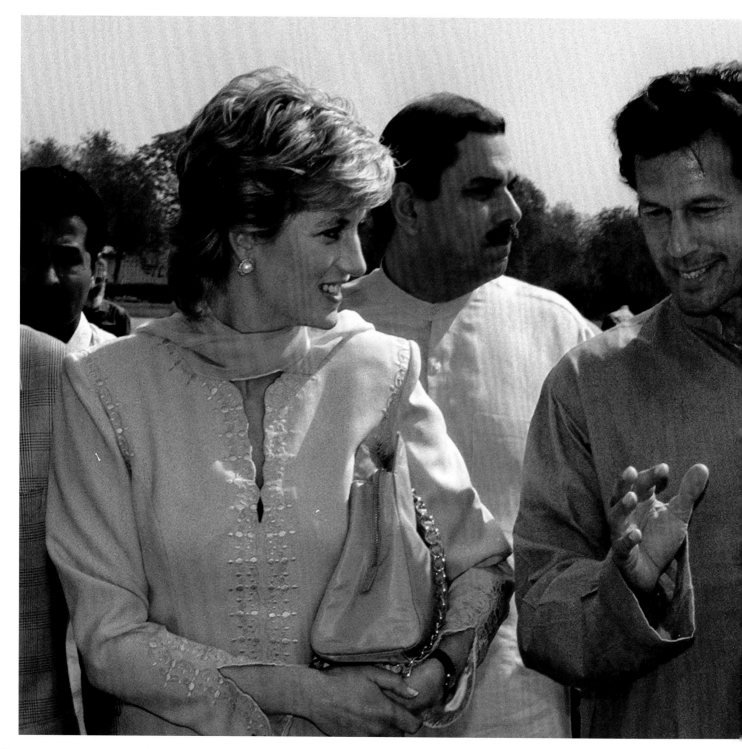

LEFT: Imran Khan, Pakistani politician and cricket star, welcomes Diana at Lahore airport in February 1997. Diana, wearing a traditional pink *shalwar kameez,* held an interest in Islamic culture. She also had fallen in love with a Pakistani doctor, Hasnat Khan.

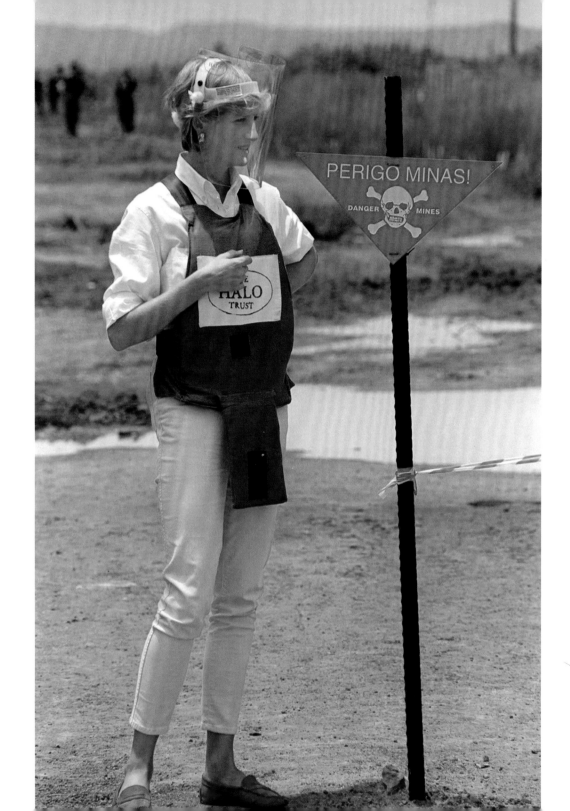

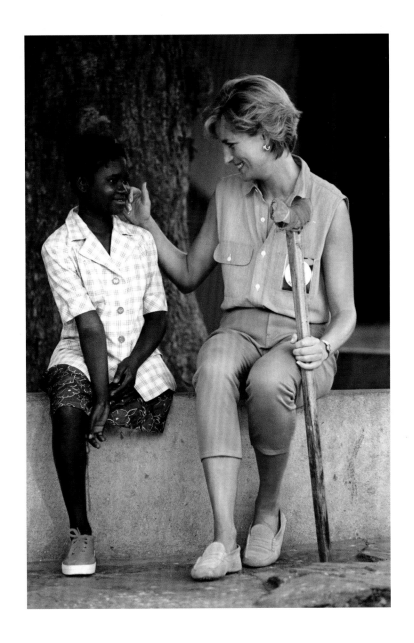

ABOVE: Diana shares a moment with Sandra Thijika during her trip to Angola to raise awareness about land mines. *January 14, 1997*

OPPOSITE: To promote her message on behalf of the charity HALO Trust, Diana walked through an active minefield in Huambo, Angola, in front of the press. The cause was more important than the inherent danger she faced. *January 15, 1997*

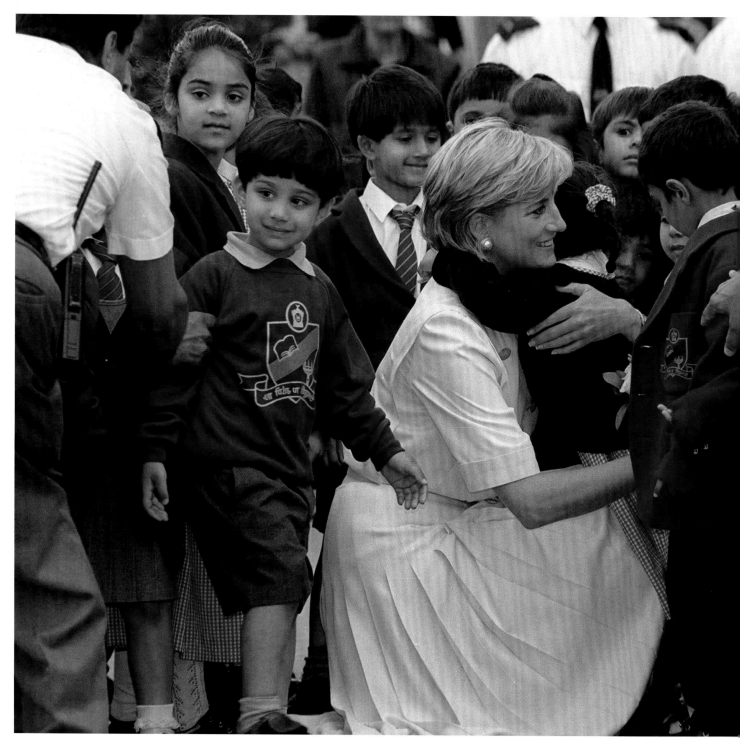

LEFT: The attraction to Diana was immediate for a young girl from the Swaminarayan School, a Hindu school in North London. *June 6, 1997*

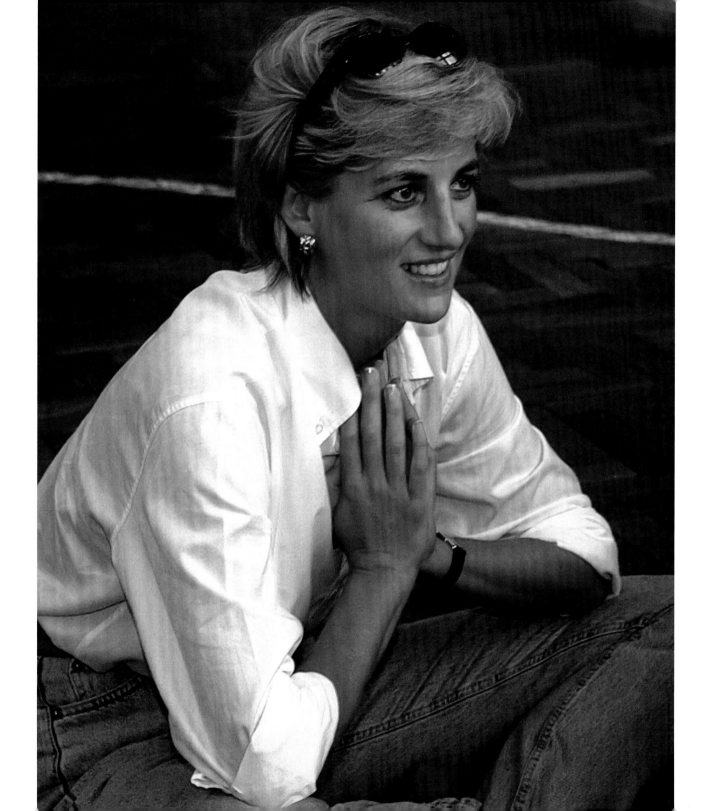

"She shared the life struggles of ordinary people. She cared about them. She was not too self-absorbed to lend her hand and her heart to people in pain or in peril, especially people with AIDS and the innocent victims of land mines."

—PRESIDENT BILL CLINTON,

DURING A RADIO ADDRESS ON SEPTEMBER 6, 1997

OPPOSITE: Pictured just a month before her death, Diana sits on a volleyball court as she talks with members of the Zenica team during a visit to Bosnia and Herzegovina. *August 1997*

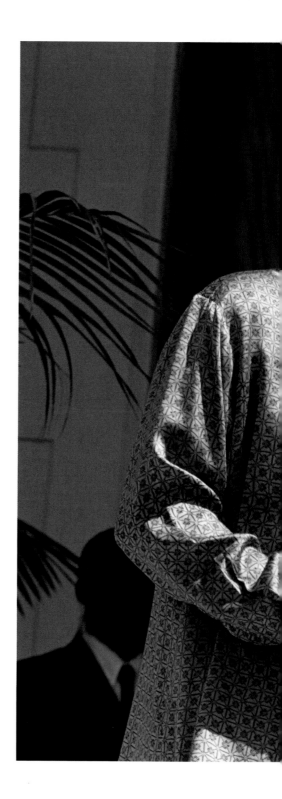

RIGHT: Diana stands with President Nelson Mandela in March 1997 while on a visit to Cape Town. *Sunday Times* reporter Christina Lamb noted that Diana "had something I'd only ever seen before in Nelson Mandela—a kind of aura that made people want to be with her, and a completely natural, straight-from-the-heart sense of how to bring hope to those who seemed to us to have little to live for."

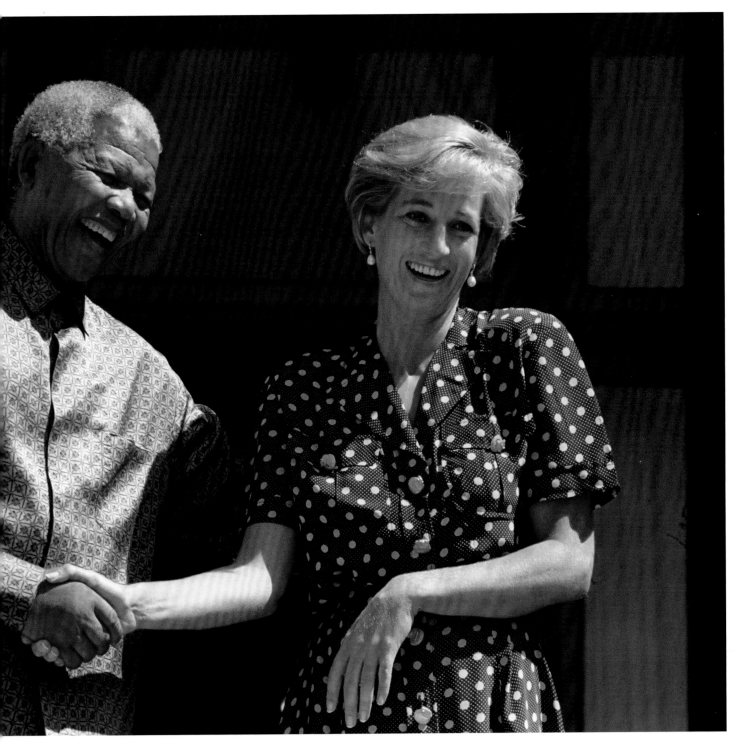

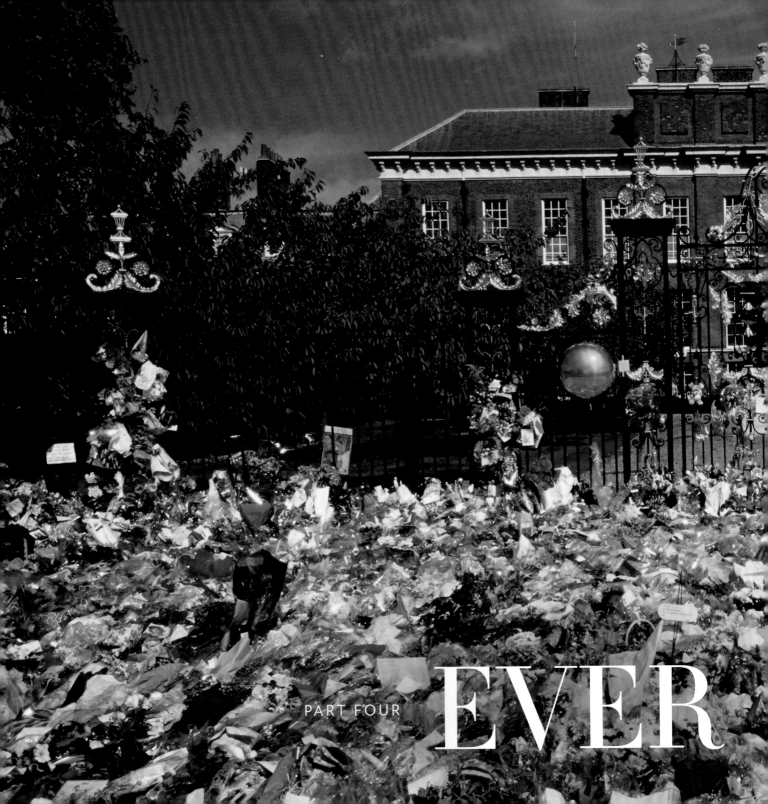

PART FOUR EVER

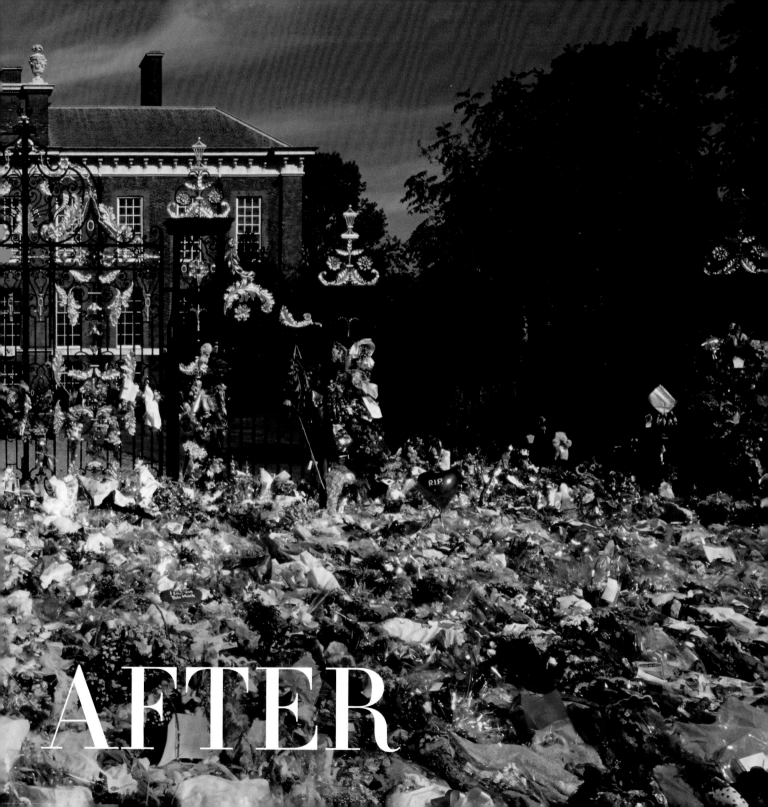

AFTER

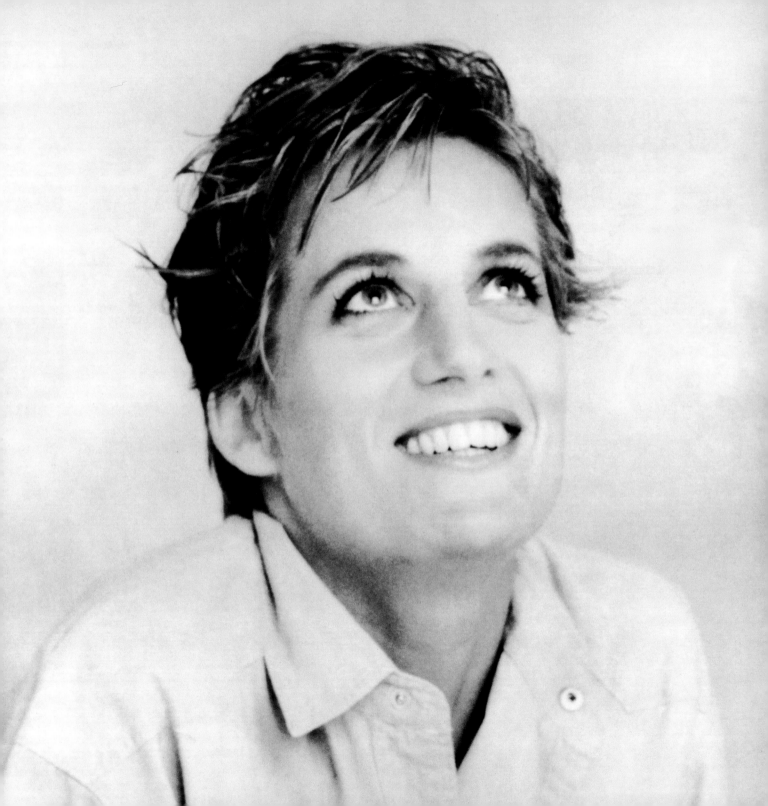

**D**iana. Her name evokes a legacy of grace and beauty, but also of vulnerability and sensitivity. For Diana didn't shy away from talking about the darker edges of her life, whether that was her loneliness within her marriage or her eating disorder. Her tragic death in the early hours of August 31, 1997, after a violent car accident in the tunnel beneath the Pont de l'Alma in Paris, left the world reeling. It was easy to point fingers; at the paparazzi who hounded her throughout her short life; at her decision to forgo security officials from Buckingham Palace and rely instead on those of her millionaire boyfriend, Dodi Al Fayed; or, even darker for those who enjoy conspiracies, at the royal family itself. But the truth is simple, Diana's too-early death broke the hearts of millions. The global outpouring of grief as the news reached every corner of the world had no parallel. The masses who flowed onto the streets of London, the endless bouquets of flowers left at the gates of Buckingham Palace, and the tear-streaked faces of admirers glued to the evening news were all reminders of what a remarkable and beloved figure she was.

Diana's hold on the public, and their love for her, lives on. As then prime minister Tony Blair eloquently remarked, "She touched the lives of so many others in Britain and throughout the world with joy and with comfort . . . She was the People's Princess and that is how she will stay, how she will remain in our hearts and our memories forever."

---

OPPOSITE: Diana's natural beauty shines in this 1991 studio portrait taken by Lord Snowden (Antony Armstrong-Jones), the renowned photographer of the royal family.

PREVIOUS PAGES: There was an overwhelming outpouring of grief after the world heard of Diana's death. More than one million bouquets of flowers—as well as stuffed animals, balloons, and even bottles of champagne—were left at Kensington Palace (pictured), Buckingham Palace, and St. James's Palace in the princess's honor.

RIGHT: A couple embraces in the crowd of mourners waiting outside Westminster Abbey during Princess Diana's funeral. After a eulogy by her brother, Charles Spencer, the congregation of 2,000 heard what sounded like soft raindrops. In reality, it was the applause of the crowd outside. *September 6, 1997*

FOLLOWING PAGES: Diana's coffin leaves Buckingham Palace for Westminster Abbey, passing a banner that reads "Diana of Love." A small ceremony was out of the question; the world would not allow it.

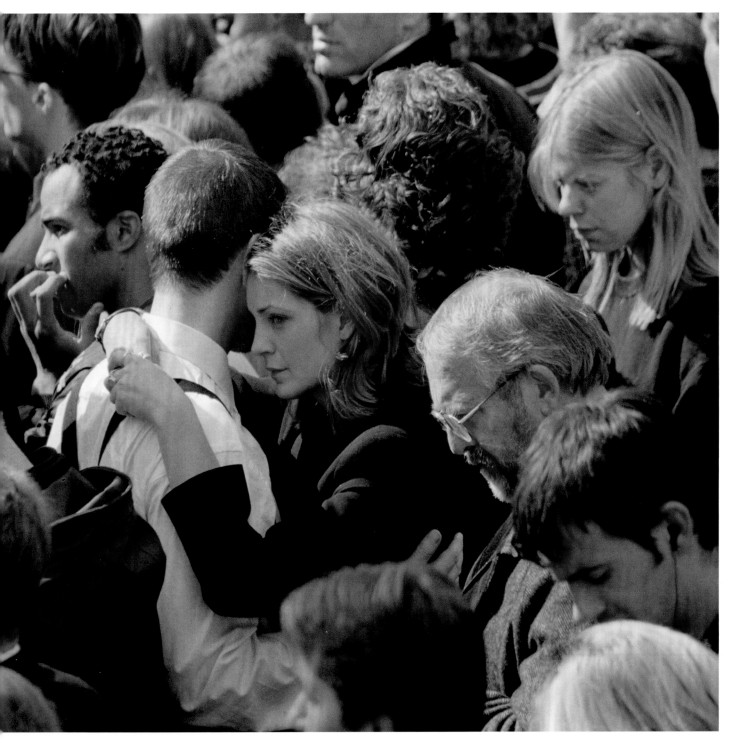

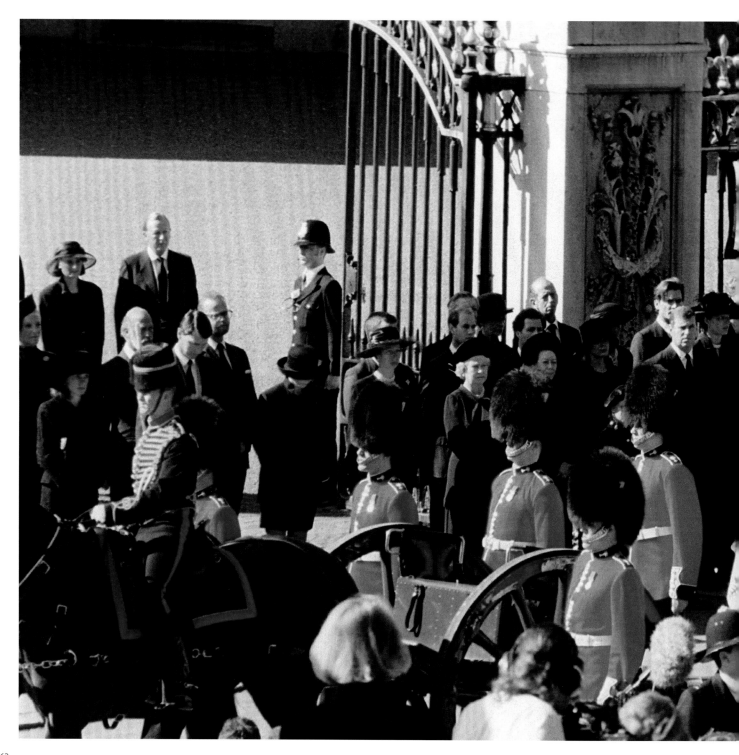

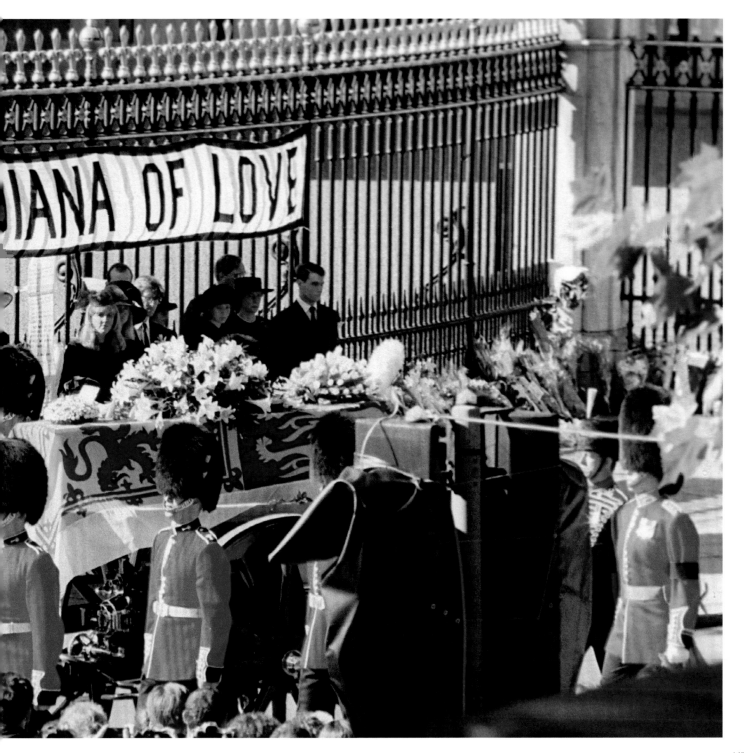

"From my position as her most senior adviser, I could clearly see that even on a bad day she usually gave far more—to her country, her family, and her staff—than she took for herself."

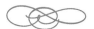

—PATRICK JEPHSON,

AS REMEMBERED IN *THE PEOPLE'S PRINCESS*

OPPOSITE: A police officer lays flowers in front of the Buckingham Palace gates.
The outpouring of grief was spontaneous and electric; it showed Diana's transcendent power.

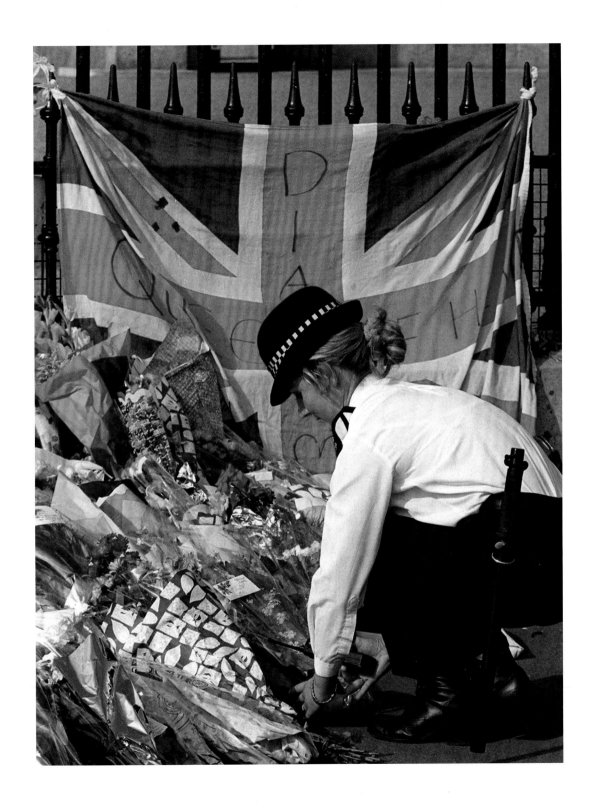

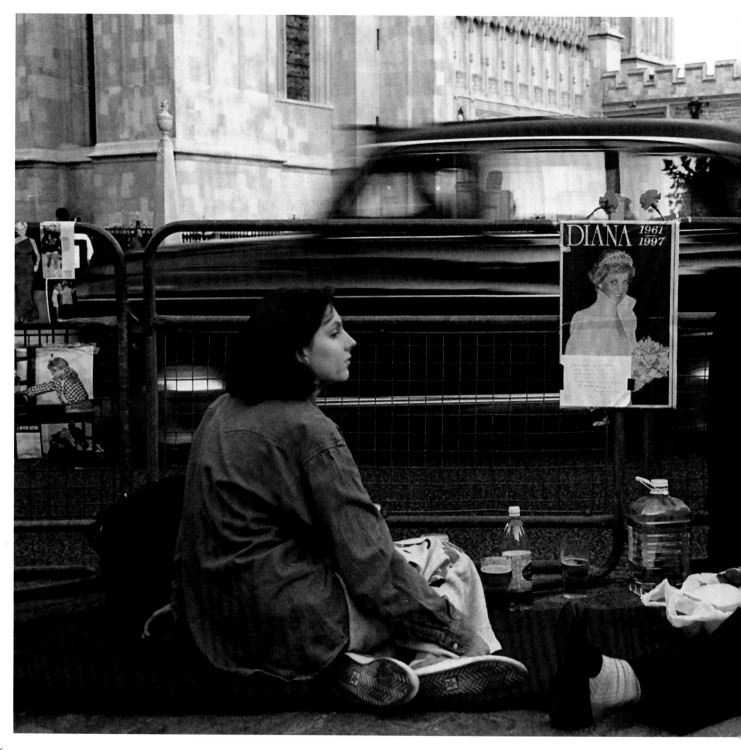

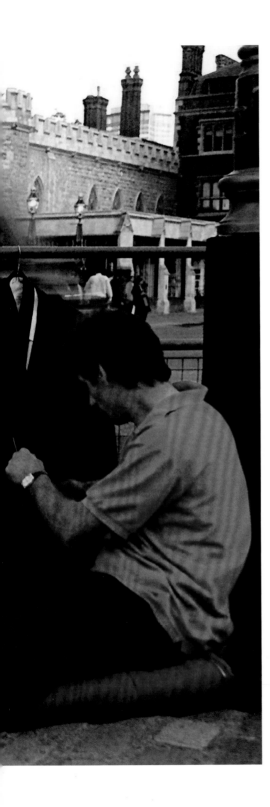

LEFT: A couple camps out in front of Westminster Abbey two days before Diana's funeral. Prince Charles had flown to Paris with Diana's sisters to bring back her body.

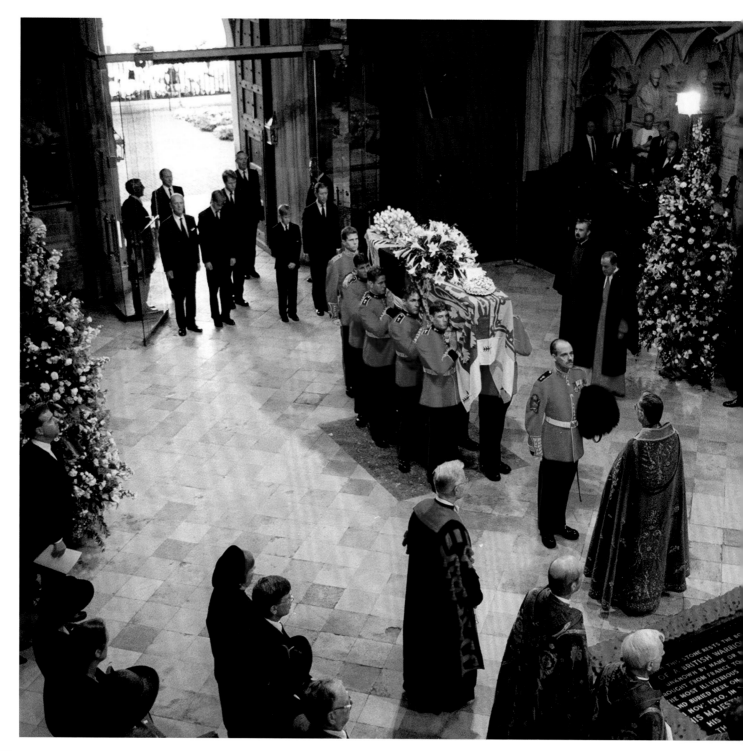

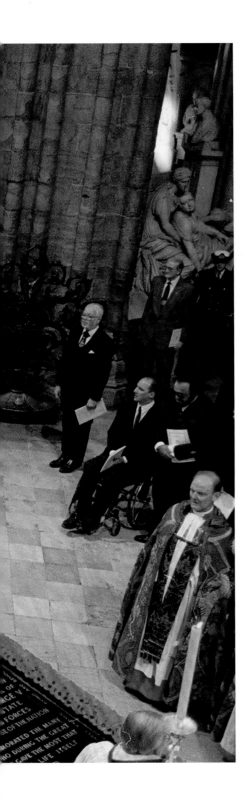

"Carry out a random act of kindness, with no expectation of reward, safe in the knowledge that one day someone might do the same for you."

—PRINCESS DIANA

LEFT: Soldiers carry Diana's lead-lined casket into Westminster Abbey. Her coffin was draped in the royal standard, with white tulips from William, white roses from Harry, and white lilies from her brother Charles.

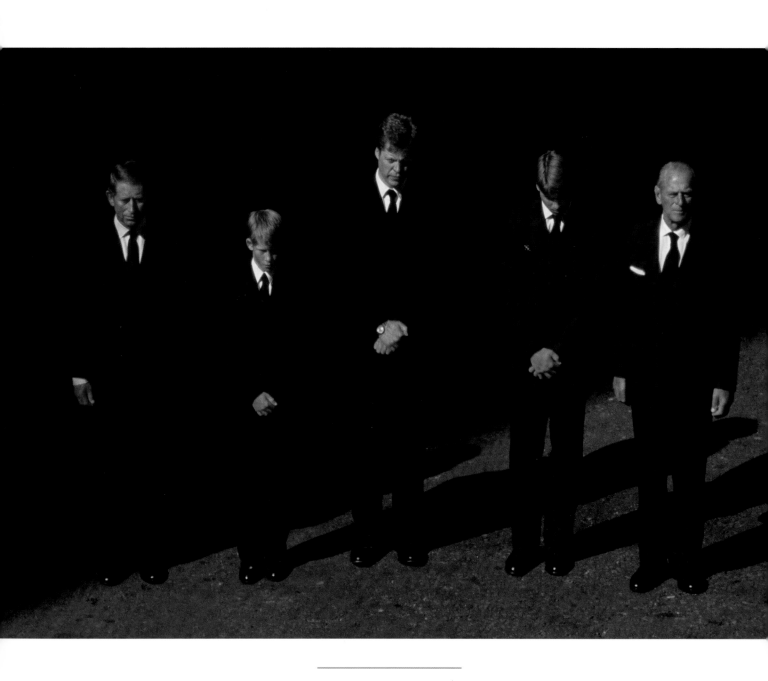

The men who were pillars in Diana's life bow their heads in silent mourning at the funeral (from left to right)
Prince Charles, Prince Harry, Earl Spencer, Prince William, and Philip, Duke of Edinburgh.

Diana was the very essence of compassion, of duty, of style, of beauty. All over the world she was a symbol of selfless humanity. All over the world, a standard bearer for the rights of the truly downtrodden, a very British girl who transcended nationality. Someone with a natural nobility who was classless and who proved in the last year that she needed no royal title to continue to generate her particular brand of magic.

"For all the status, the glamour, the applause, Diana remained throughout her life a very insecure person at heart, almost childlike in her desire to do good for others so she could release herself from deep feelings of unworthiness, of which her eating disorders were merely a symptom.

"The world sensed this part of her character and cherished her for the vulnerability whilst admiring her for her honesty.

"My own and only explanation is that genuine goodness is threatening to those at the opposite end of the moral spectrum. It is a point to remember that of all the ironies about Diana, perhaps the greatest was this—a girl given the name of the ancient goddess of hunting was, in the end, the most hunted person of the modern age."

—EARL CHARLES SPENCER,

IN HIS EULOGY AT HIS SISTER'S FUNERAL

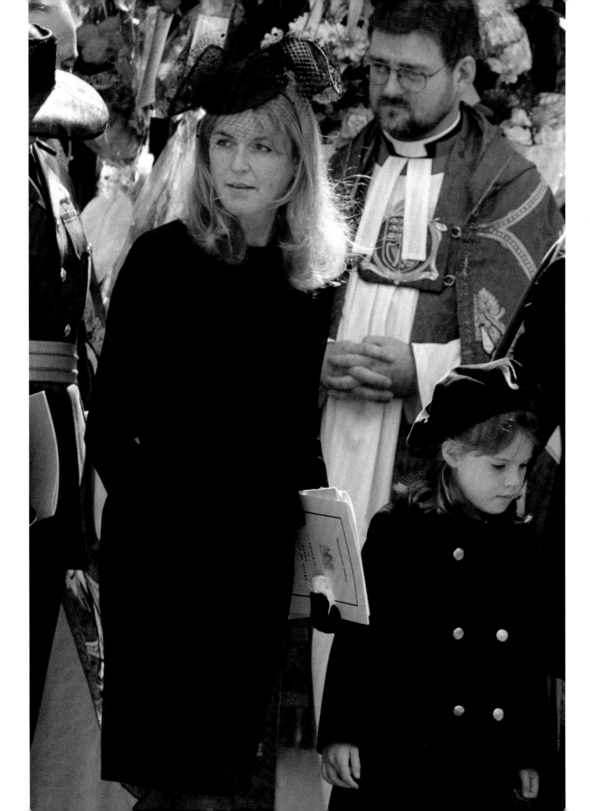

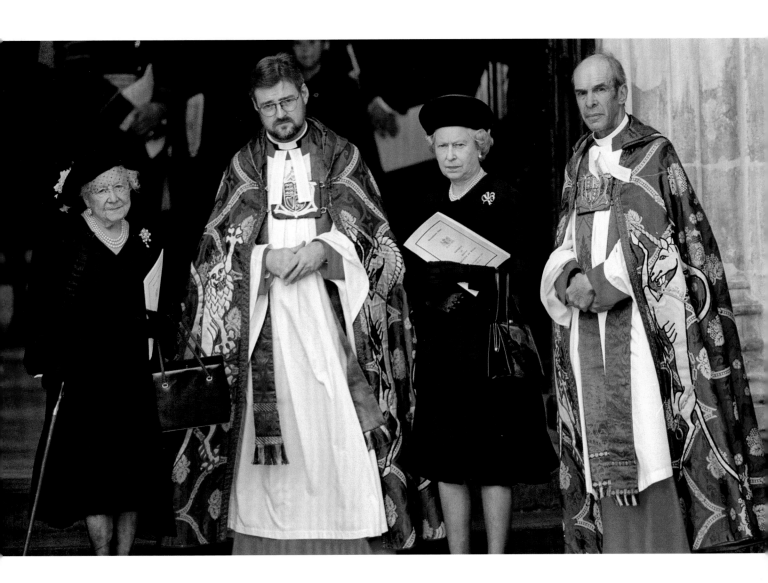

ABOVE: Queen Elizabeth II and the Queen Mother (left) stand outside Westminster Abbey before the funeral.

OPPOSITE: Sarah Ferguson, Duchess of York, and her daughter Princess Eugenie leave Westminster Abbey after Diana's funeral service. The service brought together people from all aspects of her life: the royal family, celebrities, old friends, and colleagues who worked with Diana on charity causes.

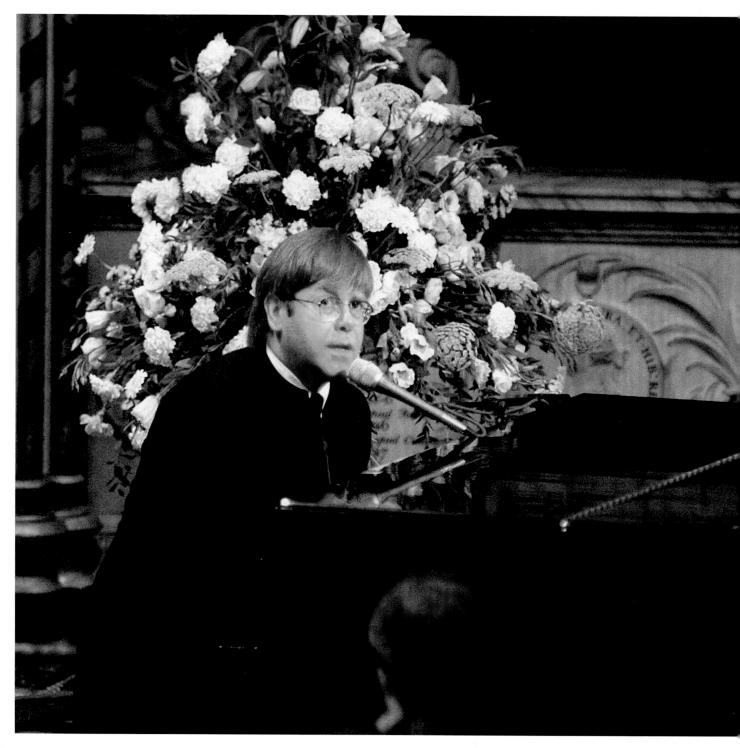

"Goodbye England's rose
May you ever grow in our hearts
You were the grace that placed itself
Where lives were torn apart
You called out to our country
And you whispered to those in pain
Now you belong to heaven
And the stars spell out your name.
And it seems to me you lived your life
Like a candle in the wind."

—ELTON JOHN AND BERNIE TAUPIN

"CANDLE IN THE WIND 1997,"
AS PLAYED AT DIANA'S FUNERAL

OPPOSITE: Elton John, a close friend, sings a revised version of "Candle in the Wind" at Diana's funeral. The original song was written as a requiem for Marilyn Monroe, one of Diana's favorite stars, who uncannily died at the same age.

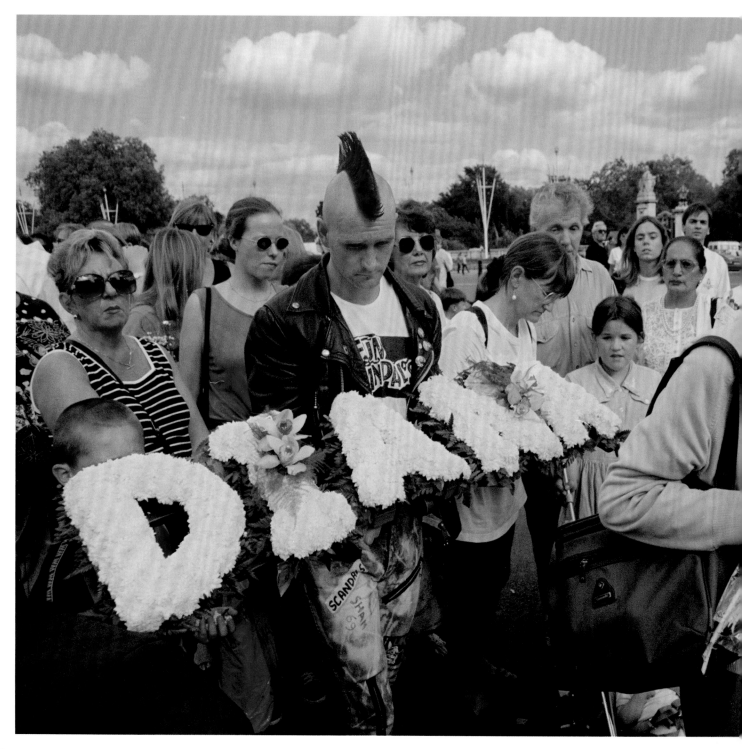

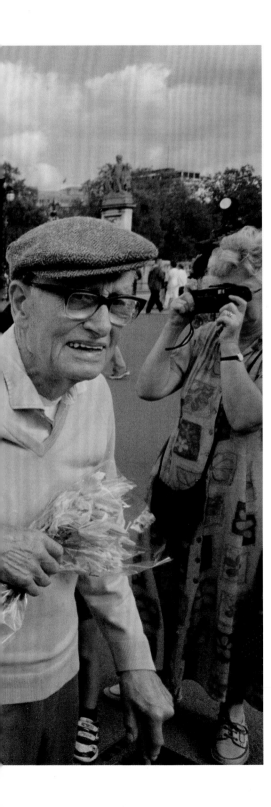

LEFT: An eclectic group of mourners carry their tributes to Diana toward Buckingham Palace on September 2, four days before her funeral.

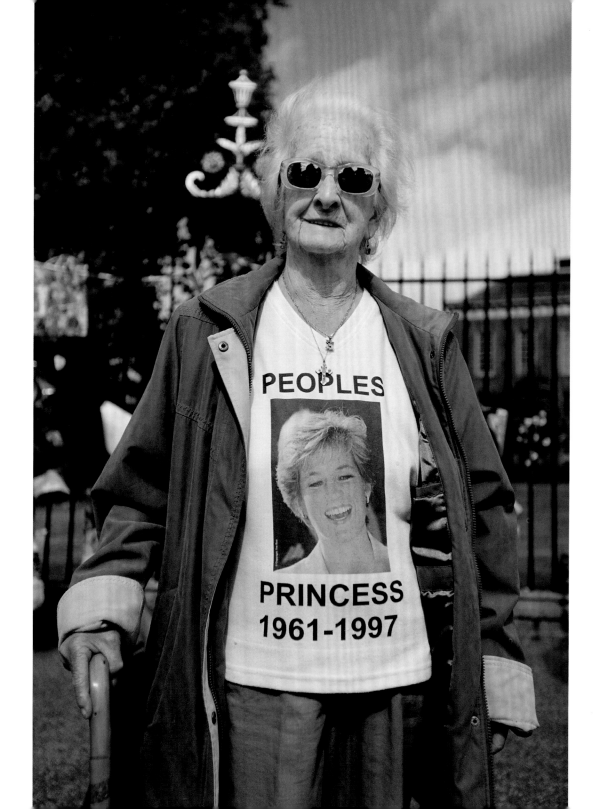

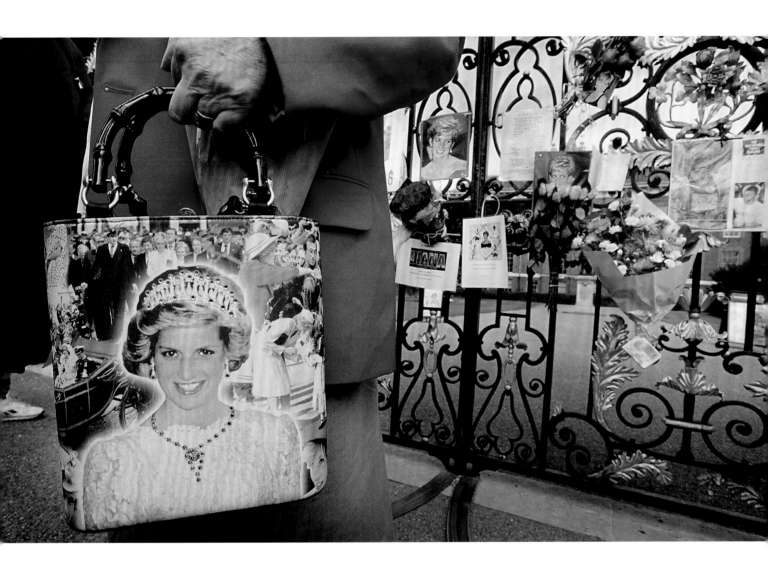

ABOVE: A woman holds a handbag featuring Lady Di on August 31, 2009,
outside Kensington Palace to mark the 12th anniversary of her death.

OPPOSITE: Diana's life and legacy deeply affected people all over the world, young and old.
Here a woman wears a commemorative T-shirt on the 12th anniversary of her death
as fans gather in London to celebrate her life.

RIGHT: Di in the sky. A day before her funeral, pilot Greg Stinis encapsulates "Di" inside a heart above Los Angeles. *September 5, 1997*

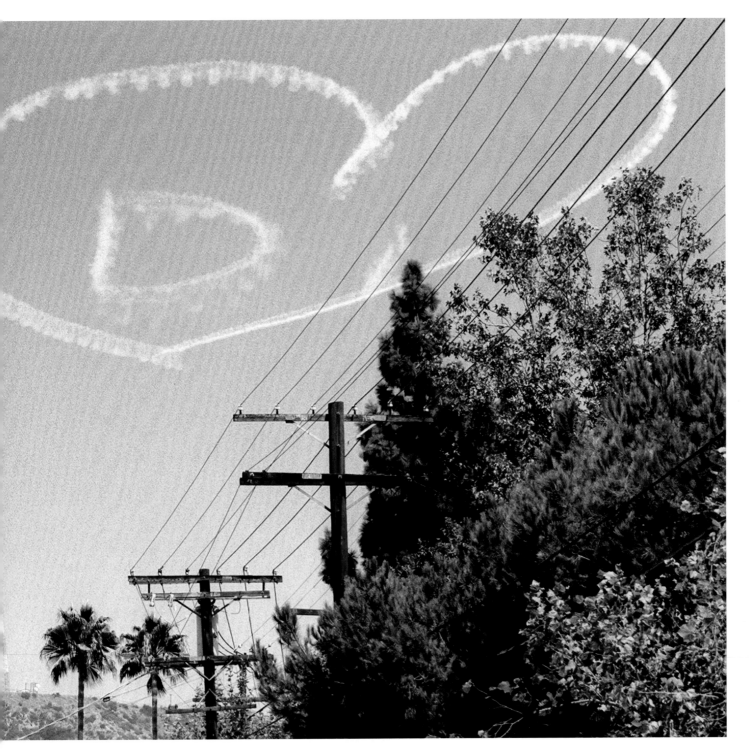

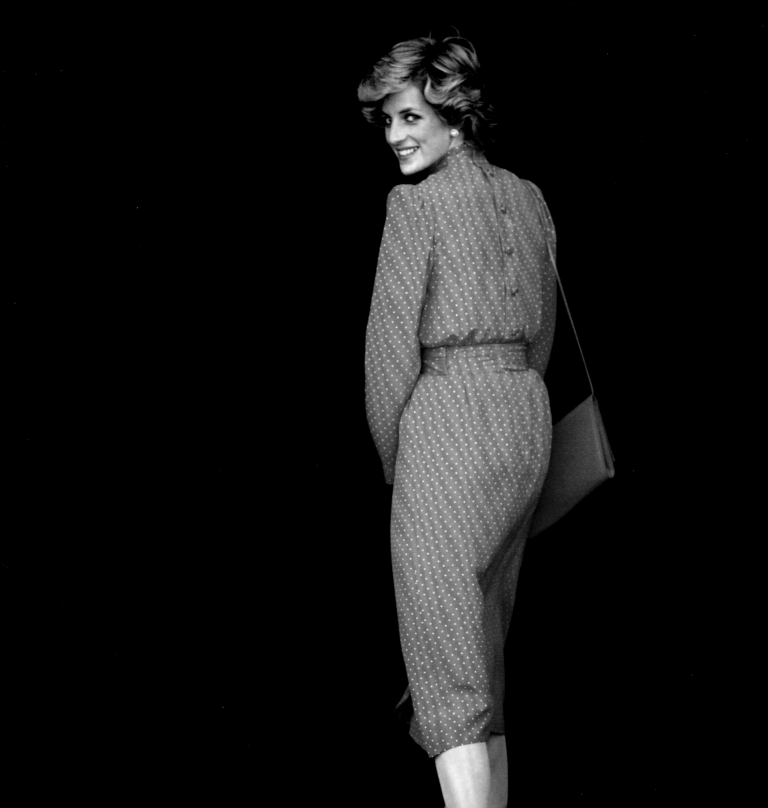

# A LIFE REMEMBERED

Twenty years after her death, Diana Spencer continues to fascinate the world. Her break from formality and her charm forever changed the way we saw the royal family. And just as decades ago we watched her every move, a rapt audience continues to pay close attention to the two young sons she left behind.

Prince William and Prince Harry have continued their mother's legacy of charitable giving, of approachability, and of handling the media. In April 2011, an estimated 23 million people tuned in to watch Prince William marry his elegant college sweetheart Kate Middleton—a ratings record that beat his parents' wedding 30 years before his. And with the birth of Prince George and Princess Charlotte, admirers the world over have found a new royal family to celebrate.

The Diana, Princess of Wales, Memorial Fund, established within days of her death, continues to support the causes dear to her. Since 1997, the foundation has awarded more than 100 million pounds to causes like palliative care and alternatives to prison for women and children. It also worked to create a global ban on cluster munitions. While Diana didn't live to see this decree, signed by 94 countries in 2008, in action, her efforts were integral to its success.

Meanwhile, Diana's work and legacy live on. As she herself wished in 1995, she will always remain "the queen of people's hearts."

---

OPPOSITE: Diana looks over her shoulder during a visit to Rome. *April 29, 1985*

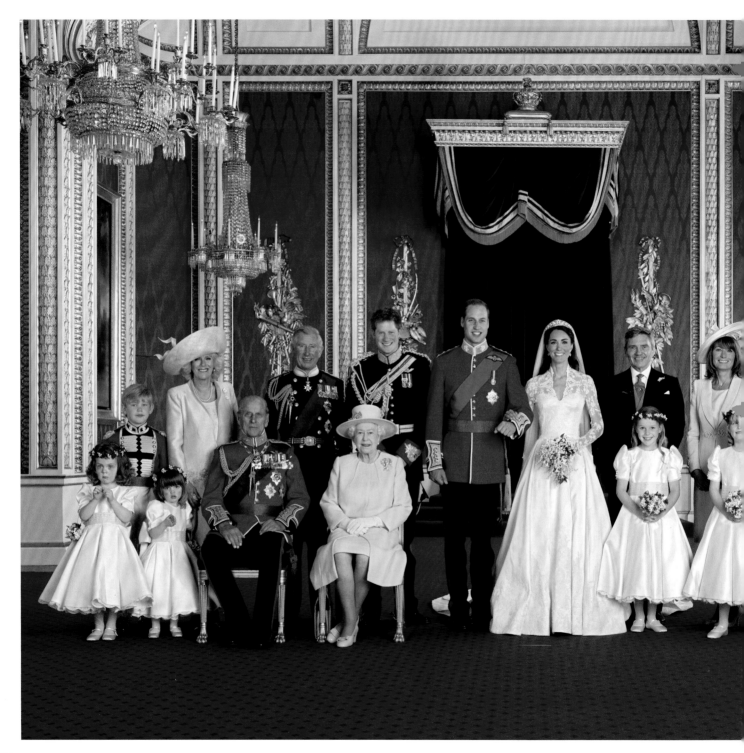

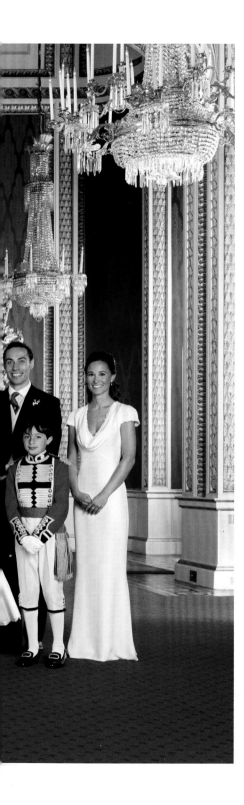

LEFT: In this official photo, issued by St. James's Palace, Prince William and Catherine (better known as Kate Middleton), Duchess of Cambridge, pose at their wedding. Prince Harry stands between his brother and his father, Prince Charles. Decades after their mother's death, the two young princes and the royal family continue to fascinate the public.

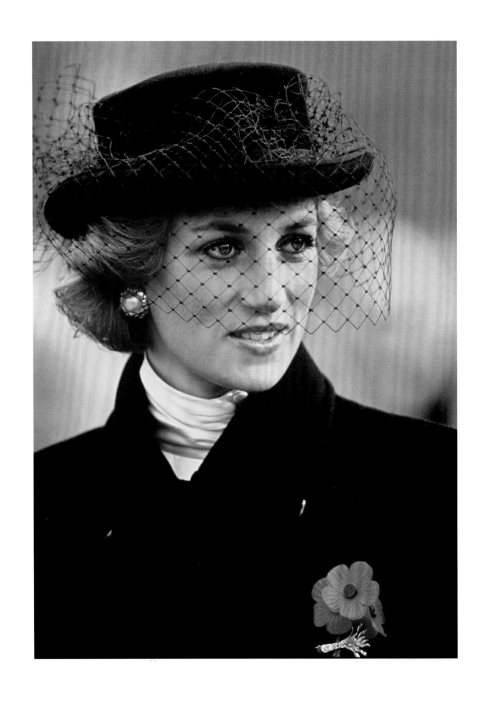

Diana, in a Viv Knowland veiled hat, smiles during a French armistice commemoration on November 11, 1988, in Paris.

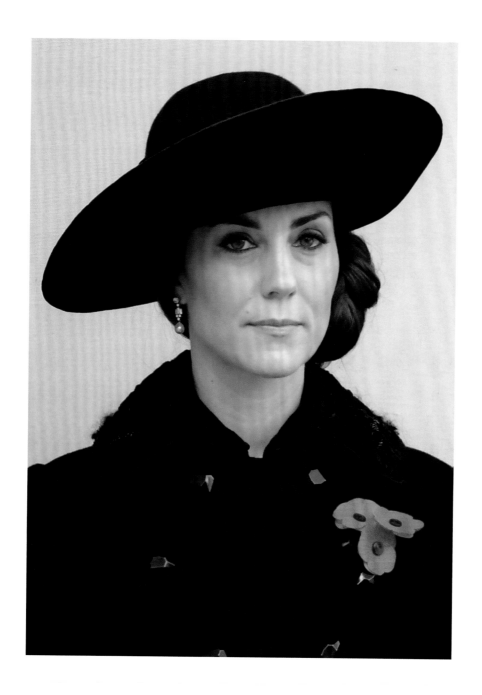

The Duchess of Cambridge is often compared—in both fashion and personality—to her beloved mother-in-law. Here, she dresses similarly during a Remembrance Sunday Service at the Cenotaph in Whitehall. *November 2016*

RIGHT: Following his mother's humanitarian example, William, with Kate, visits the Pan Bari agricultural village in Kaziranga National Park, India. His mother's passion for the well-being of others is a legacy he has worked hard to continue. *April 2016*

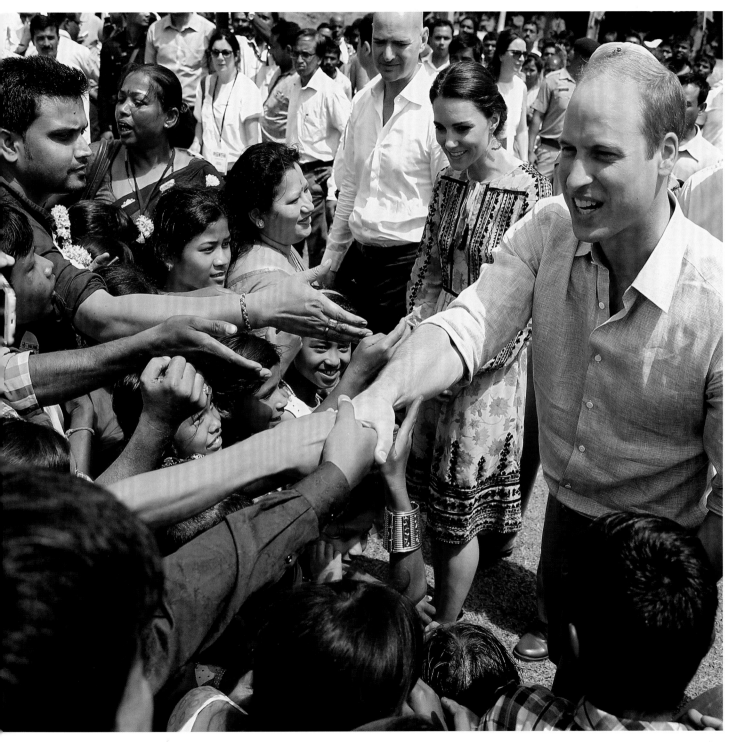

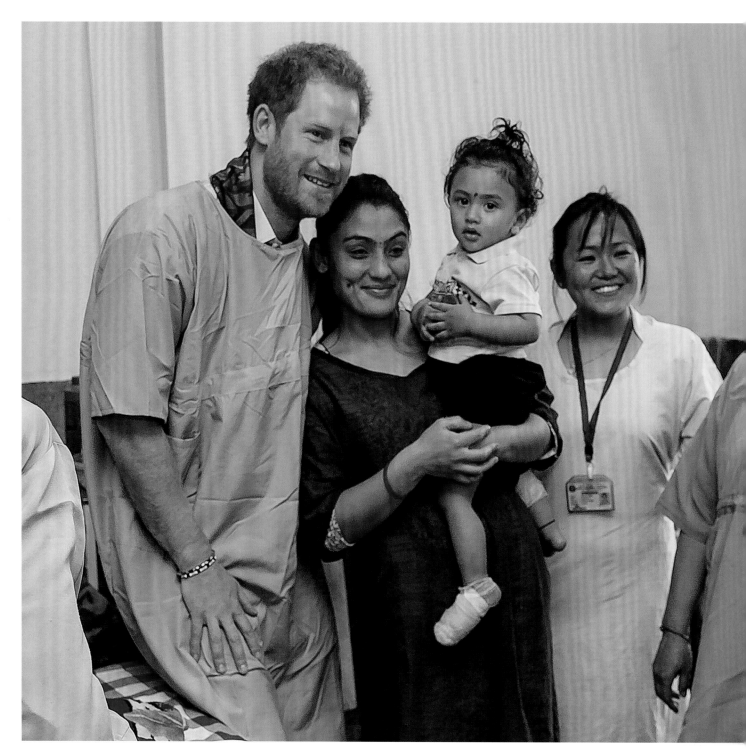

LEFT: Like his mother before him, Prince Harry (at left) has a unique ability to connect with those he meets. Here, he visits with staff and patients at the Kanti Children's Hospital in Kathamandu, Nepal, where children recover from a 7.8 magnitude earthquake that hit their village. *March 23, 2016*

"I still miss my mother every day—
and it's 20 years after she died."

—PRINCE WILLIAM,

AT KEECH HOSPICE CARE IN LUTON, AUGUST 2016

OPPOSITE: Kate, Princess Charlotte, William, and Prince George pose for a portrait during a family ski vacation in the French Alps. Just as Diana had done with her children, the royal couple has worked to make sure that their own children are not consumed by the media's fascination with the royal family. *March 3, 2016*

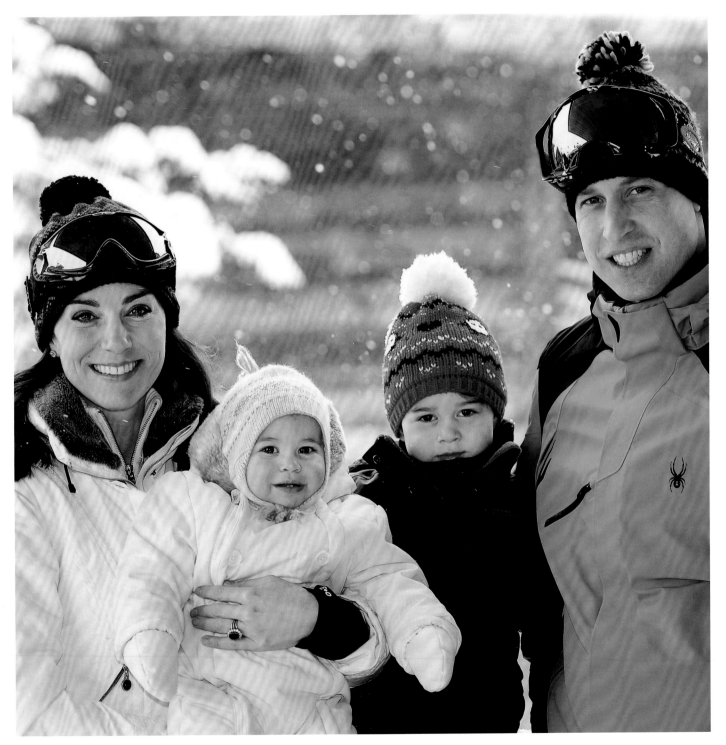

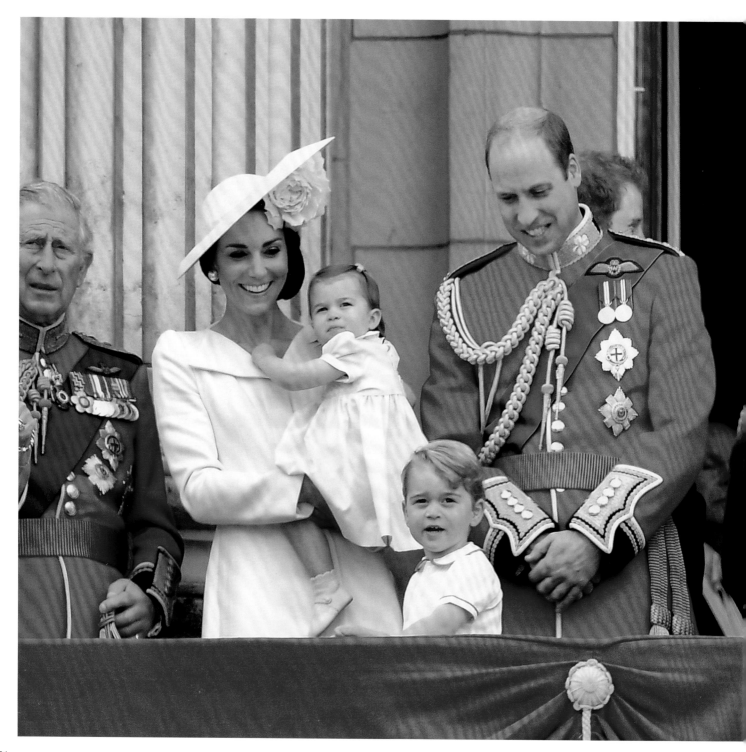

## CLASSIC DIANA

T oday the royal family—even with the finery of royal military titles and the pomp of tradition—has captivated the hearts of millions, mostly because of how relatable they seem. Diana's life paved the way for this "new version" of the royals and their relationship with the media. She broke the barriers of class, race, and nationality and left the doors open for her children to follow. Here, the royal family, including Prince William, Kate, their children, and the Queen, attend the Trooping the Color annual parade marking Queen Elizabeth II's 90th birthday at the Mall in London on June 11, 2016.

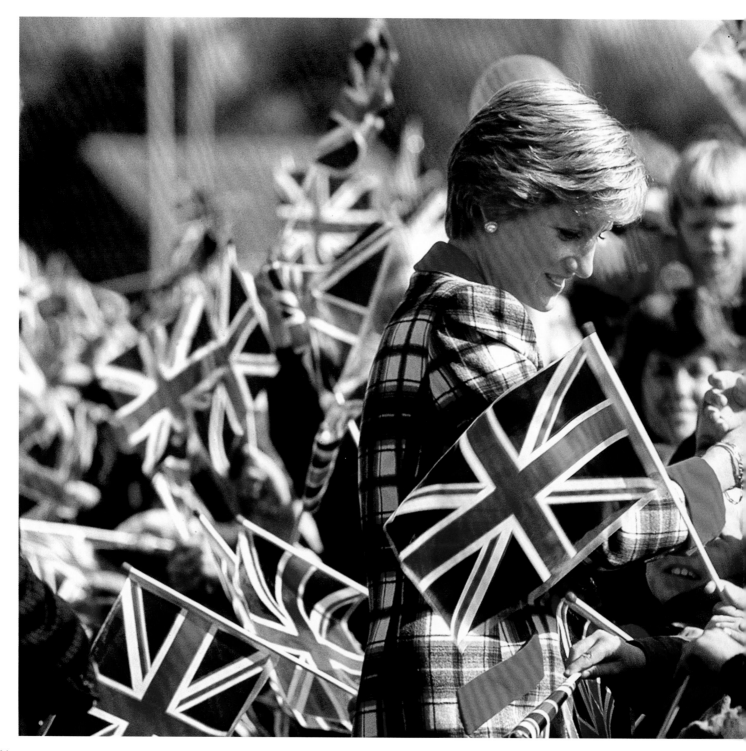

"I knew what my job was; it was to go out and meet the people and love them."

—PRINCESS DIANA

LEFT: Enthusiastic crowds greet Diana with flags waving during her visit to Cullompton in Devon. Lady Di was a princess for the people, transcending all barriers to reach out and make a difference in the world around her. *September 1990*

# SOURCES

"Diana, Princess of Wales, Exhibition With Mario Testino." In *BBC Breakfast*. BBC. 2005

Part One: Once Upon a Time
Bashir, Martin. "Interview With Princess Diana." Transcript. In *Panorama*. BBC. November 20, 1995.
Bradford, Sarah. *Diana*. New York: Viking, 2006.
King, Larry. *The People's Princess: Cherished Memories of Diana, Princess of Wales, From Those Who Knew Her Best*. New York: Crown Publishers, 2007.
*My Mother Diana: Prince William's Story of Diana's Influence*. Directed by Patrick Reams. XiveTV. 2015.

Part Two: Inside the Fairy Tale
Bashir, Martin. "Interview With Princess Diana." Transcript. In *Panorama*. BBC. November 20, 1995.
BBC on This Day, "1981: Charles and Diana Marry." BBC News. July 29, 1981. http://news.bbc.co.uk/onthisday/hi/dates/stories/july/29/newsid_2494000/2494949.stm.
Foster, Max. "Prince William's Passion: New Father, New Hope." Transcript. CNN. September 15, 2013.
"In Full: Harry's Tribute to Diana." BBC News. August 31, 2007. http://news.bbc.co.uk/2/hi/uk_news/6972412.stm.
"Interview With Elton John." Transcript. In *Larry King Live*. CNN. January 25, 2002.
King, Larry. *The People's Princess: Cherished Memories of Diana, Princess of Wales, From Those Who Knew Her Best*. New York: Crown Publishers, 2007.
Odone, Cristina. "Mario Testino: 'When I Met Diana, I Knew From the Start That This Shoot Would Be Different.'" *Telegraph*. January 18, 2014. http://www.telegraph.co.uk/news/newstopics/diana/10581078/Mario-Testino-When-I-met-Diana-I-knew-from-the-start-that-this-shoot-would-be-different.html.

Part Three: The People's Princess
Brunner, Jeryl. "Remembering Princess Diana in Her Own Words." *Parade*. December 20, 2016. http://parade.com/504344/jerylbrunner/remembering-princess-diana-in-her-own-words.

Clinton, Bill. *Public Papers of the Presidents of the United States, William J. Clinton: 1997 (in two books) book 2, July 1 to December 31, 1997*. Washington, D.C.: U.S. Government Printing Office, 1999.
Cooper, Anderson, and Dunne, Dominick. "Larry King: 50 Years of Pop Culture." Transcript. In *Larry King Live*. CNN. May 3, 2007.
King, Larry. *The People's Princess: Cherished Memories of Diana, Princess of Wales, From Those Who Knew Her Best*. New York: Crown Publishers, 2007.

Part Four: Ever After
"Blair Pays Tribute to Diana." BBC News. September 1, 1997. http://www.bbc.co.uk/news/special/politics97/diana/blairreact.html.
Brunner, Jeryl. "Remembering Princess Diana in Her Own Words." *Parade*. December 20, 2016. http://parade.com/504344/jerylbrunner/remembering-princess-diana-in-her-own-words.
King, Larry. *The People's Princess: Cherished Memories of Diana, Princess of Wales, From Those Who Knew Her Best*. New York: Crown Publishers, 2007.
Spencer, Earl Charles. "Full Text of Earl Spencer's Funeral Oration." BBC News. September 7, 1997. http://www.bbc.co.uk/news/special/politics97/diana/spencerfull.html.

Epilogue: A Life Remembered
Brunner, Jeryl. "Remembering Princess Diana in Her Own Words." *Parade*. December 20, 2016. http://parade.com/504344/jerylbrunner/remembering-princess-diana-in-her-own-words.
Sawer, Patrick. "Duke of Cambridge Opens Up About Losing His Mother While Comforting Boy, 14, Who Underwent Some Trauma." *Telegraph*. August 24, 2016. http://www.telegraph.co.uk/news/2016/08/24/duke-of-cambridge-opens-up-about-losing-his-mother-while-comfort.

# ILLUSTRATIONS CREDITS

Front and back cover photographs by Mario Testino; back flap, © Brigitte Lacombe; 2, Mario Testino/Art Partner; 4, © Armstrong Jones/Reproduced with permission of Trunk Archive; 6, Bettman/Getty Images; 20-21, Tim Graham/Getty Images; 22, Bettman/Getty Images; 24-5, Popperfoto/Getty Images; 26, Hulton Archive/Getty Images; 27, Central Press/Getty Images; 28-9, Associated Press; 31, (Spen/AL)/Camera Press/Redux Pictures; 32-3, Keystone/Getty Images; 34, (Spen/AL)/Camera Press/Redux Pictures; 35, (Spen/AL)/Camera Press/Redux Pictures; 36, (Spen/AL)/Camera Press/Redux Pictures; 37, (Spen/AL)/Camera Press/Redux Pictures; 38, Central Press/Getty Images; 40-41, Hulton Archive/Getty Images; 42, REX/Shutterstock; 44-5, Trinity Mirror/Mirrorpix/Alamy Stock Photo; 46, celebrity/Alamy Stock Photo; 47, Tom Stoddart/Getty Images; 48, Serge Lemoine/Getty Images; 50-1, Keystone-France/Getty Images; 52, Tim Graham/Getty Images; 54-5, Wally McNamee/Getty Images; 56, Keystone-France/Getty Images; 58-9, Lichfield/Getty Images; 60-61, Popperfoto/Getty Images; 62-3, Lichfield/Getty Images; 64, Tim Graham/Getty Images; 66, Tim Graham/Getty Images; 67, Tim Graham/Getty Images; 68-9, Tim Graham/Getty Images; 70-71, Georges De Keerle/Getty Images; 73, Anwar Hussein/Getty Images; 74, Jayne Fincher/Princess Diana Archive/Getty Images; 75, Tim Graham/Getty Images; 76-7, Jayne Fincher/Princess Diana Archive/Getty Images; 78, Jayne Fincher/Princess Diana Archive/Getty Images; 79, Tim Graham/Getty Images; 80-81, Anwar Hussein/Getty Images; 82-3, Tim Graham/Getty Images; 84-5, Anwar Hussein/Getty Images; 87, Tim Graham/Getty Images; 88-9, Tim Graham/Getty Images; 90-91, Georges DeKeerle/Getty Images; 92, Tim Graham/Getty Images; 93, Tim Graham/Getty Images; 95, Jayne Fincher/Princess Diana Archive/Getty Images; 96, Dave M. Benett/Getty Images; 97, Pool APESTEGUY/DUCLOS/SOLA/Gamma-Rapho/Getty Images; 98-9, Anwar Hussein/Getty Images; 101, Bob Thomas/Getty Images; 102-103, Tim Graham/Getty Images; 104-105, Mario Testino/Art Partner; 106, Tim Graham/Getty Images; 108-109, Tim Graham/Getty Images; 110-11, Princess Diana Archive/Getty Images; 112, Princess Diana Archive/Getty Images; 113, Tim Graham/Getty Images; 114-15, Jayne Fincher/Princess Diana Archive/Getty Images; 116-17, Princess Diana Archive/Getty Images; 118-19, Julian Parker/UK Press /Getty Images; 120-121, Anwar Hussein/Getty Images; 122-3, Patrick Bruchet/Paris Match/Getty Images; 124-5, Terry Fincher/Princess Diana Archive/Getty Images; 126-7, Emmanuel Dunand/AFP/Getty Images; 128, Tim Graham/Getty Images; 130, Anwar Hussein/Getty Images; 131, Tim Graham/Getty Images; 132-3, Tim Graham/Getty Images; 135, Tim Graham/Getty Images; 136-7, Dave Benett/Getty Images; 138, Princess Diana Archive/Getty Images; 139, Julian Parker/UK Press /Getty Images; 141, Jayne Fincher/Princess Diana Archive/Getty Images; 142-3, Francis Specker/Alamy Stock Photo; 144-5, Tim Rooke/REX/Shutterstock; 146-7, Anwar Hussein/Getty Images; 148, Tim Graham/Getty Images; 149, Tim Graham/Getty Images; 150-51, Tim Graham/Getty Images; 152, Ian Waldie/Reuters; 154-5, Oryx Media Archive/Gallo Images/Getty Images; 156-7, Peter Turnley/Getty Images; 158, © Armstrong Jones/Reproduced with persmission of Trunk Archive; 160-61, Colin Davey/Getty Images; 162-3, Anwar Hussein/Getty Images; 165, Thomas Coex/AFP/Getty Images; 166-7, Gerry Penny/AFP/Getty Images; 168-9, Ken Goff/Getty Images; 170, robert wallis/Getty Images; 172, Jayne Fincher/Princess Diana Archive/Getty Images; 173, Anwar Hussein/Getty Images; 174-5, Anwar Hussein/Getty Images; 176-7, Colin Davey/Getty Images; 178, Peter Macdiarmid/Getty Images; 179, Peter Macdiarmid/Getty Images; 180-81, Hector Mata/Getty Images; 182, Tim Graham/Getty Images; 184-5, Hugo Burnand/St James's Palace—WPA Pool/Getty Images; 186, Anwar Hussein/Getty Images; 187, Karwai Tang/Getty Images; 188-9, Chris Jackson/Getty Images; 190-91, Danny Martindale/Getty Images; 193, John Stillwell/AFP/Getty Images; 194-5, James Devaney/Getty Images; 196-7, Terry Fincher/Princess Diana Archive/Getty Images.

*Remembering Diana* would not have been possible without the hard work of the wonderful National Geographic team: senior editor Hilary Black, project editor Allyson Johnson, researcher Michelle Harris, art director Sanaa Akkach, senior photo editor Moira Haney, photo editor Jill Foley, senior production editor Judith Klein, and countless others who have given their time and talent to this book.

Since 1888, the National Geographic Society has funded more than 12,000 research, exploration, and preservation projects around the world. National Geographic Partners distributes a portion of the funds it receives from your purchase to National Geographic Society to support programs including the conservation of animals and their habitats.

National Geographic Partners
1145 17th Street NW
Washington, DC 20036-4688 USA

Become a member of National Geographic and activate your benefits today at natgeo.com/jointoday.

For information about special discounts for bulk purchases, please contact National Geographic Books Special Sales: specialsales@natgeo.com

For rights or permissions inquiries, please contact National Geographic Books Subsidiary Rights: bookrights@natgeo.com

ISBN: 978-1-4262-1853-8

Printed in China

17/RRDS/1